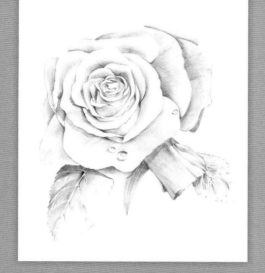

T0300694

FLOWERS

with William F. Powell

It's no wonder we're naturally attracted to flowers. Their fascinating and varied forms, colors, and textures provide a never-ending source of artistic inspiration. In this book, you'll learn the step-by-step process of rendering various types of flowers—from their basic shapes to their completed forms. You'll begin with the tools and materials needed to get started, as well as the shading techniques that will bring your flower drawings to life. With just a little practice, you'll learn to draw a wealth of flower varieties and see just how rewarding recreating these captivating subjects can be!

—William F. Powell

CONTENTS

Walter Foster

TOOLS & MATERIALS

Drawing is just like writing your name. You use lines to make shapes. In the art of drawing, you carry it a bit further, using shading techniques to create the illusion of three-dimensional form. Only a few basic tools are needed in the art of drawing. The tools necessary to create the drawings in this book are all shown here.

Pencils

Pencils are labeled based on their lead texture. Hard leads (H) are light in value and great for fine, detailed work, but they are more difficult to erase. Soft leads (B) are darker and wonderful for blending and shading, but they smudge easily. Medium leads, such as HB and F, are somewhere in the middle. Select a range of pencils between HB and 6B for variety. You can purchase wood-encased pencils or mechanical pencils with lead refills.

Wooden Pencil The most common type of pencil is wood-encased graphite. These thin rods—most often round or hexagonal when cut crosswise—are inexpensive, easy to control and sharpen, and readily available to artists.

Carpenter's Pencil

Flat Carpenter's Pencil Some artists prefer using a flat carpenter's pencil, which has a rectangular body and lead. The thick lead allows you to easily customize its shape to create both thick and thin lines.

Mechanical Pencil Mechanical pencils are plastic or metal barrels that hold individual leads. Some artists prefer the consistent feel of mechanical pencils to that of wooden pencils; the weight and length do not change over time, unlike wooden pencils that wear down with use.

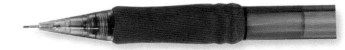

Mechanical Pencil

Woodless Graphite Pencil These tools are shaped like wooden pencils but are made up entirely of graphite lead. The large cone of graphite allows artists to use either the broad side for shading large areas or the tip for finer strokes and details.

Woodless Pencil

Graphite Stick Available in a full range of hardnesses, these long, rectangular bars of graphite are great tools for sketching (using the end) and blocking in large areas of tone (using the broad side).

Graphite Stick

Paper

Paper has a tooth, or texture, that holds graphite. Papers with more tooth have a rougher texture and hold more graphite, which allows you to create darker values. Smoother paper has less tooth and holds less graphite, but it allows you to create much finer detail. Plan ahead when beginning a new piece, and select paper that lends itself to the textures in your drawing subject.

Blending Tools

There are several tools you can use to blend graphite for a smooth look. The most popular blenders are blending stumps, tortillons, and chamois cloths. Never use your finger to blend—it can leave oils on your paper, which will show after applying graphite.

Stumps Stumps are tightly rolled paper with points on both ends. They come in various sizes and are used to blend large and small areas of graphite, depending on the size of the stump. You can also use stumps dipped in graphite shavings for drawing or shading.

Tortillons Tortillons are rolled more loosely than a stump. They are hollow and have one pointed end. Tortillons also come in various sizes and can be used to blend smaller areas of graphite.

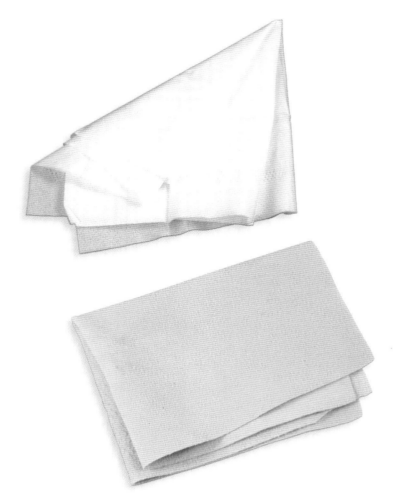

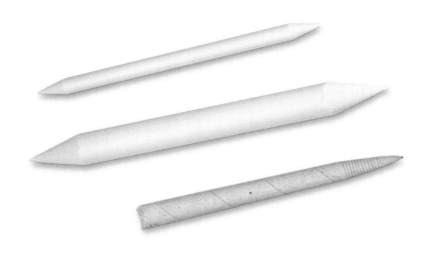

Facial Tissue Wrap tissue around your finger or roll it into a point to blend when drawing very smooth surfaces. Make sure you use plain facial tissue, without added moisturizer.

Chamois Chamois are great for blending areas into a soft tone. These cloths can be used for large areas or folded into a point for smaller areas. When the chamois becomes embedded with graphite, simply throw it into the washer or wash by hand. Keep one with graphite on it to create large areas of light shading. To create darker areas of shading, add graphite shavings to the chamois.

Erasers

Erasers serve two purposes: to eliminate unwanted graphite and to "draw" within existing graphite. There are many different types of erasers available.

Kneaded This versatile eraser can be molded into a fine point, a knife-edge, or a larger flat or rounded surface. It removes graphite gently from the paper but not as well as vinyl or plastic erasers.

Block Eraser A plastic block eraser is fairly soft, removes graphite well, and is very easy on your paper. Use it primarily for erasing large areas, but it also works quite well for doing a final cleanup of a finished drawing.

Stick Eraser Also called "pencil erasers," these handy tools hold a cylindrical eraser inside. You can use them to erase areas where a larger eraser will not work. Using a utility razor blade, you can trim the tip at an angle or cut a fine point to create thin white lines in graphite. It's like drawing with your eraser!

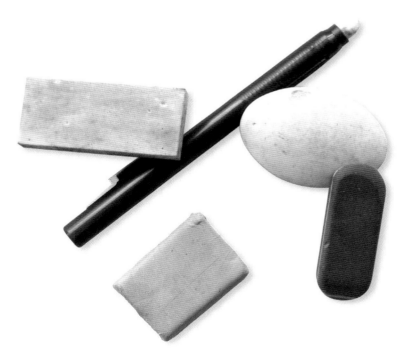

SHADING TECHNIQUES

Shading enables you to transform mere lines and shapes in your drawing into three-dimensional objects. As you read through this book, note how the words *shape* and *form* are used. *Shape* refers to the actual outline of an object, while *form* refers to its three-dimensional appearance.

Gradating with Pressure A gradation is a transition of tone from dark to light. To create a simple gradation using one pencil, begin with heavier pressure and gradually lighten it as you stroke back and forth. Avoid pressing hard enough to score or completely flatten the tooth of the paper.

This is an oval shape.

Gradating with Hardness Because different pencil hardnesses yield different values, you can create a gradation by using a series of pencils. Begin with soft, dark leads and switch to harder, grayer tones as you move away from the starting point.

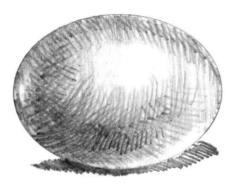

This has a three-dimensional, ball-like form.

Stippling Apply small dots of graphite for a speckled texture. To prevent this technique from appearing too mechanical, subtly vary the dot sizes and distances from each other.

Scumbling This organic shading method involves scribbling loosely to build up general tone. Keep your pressure light and consistent as you move the pencil in random directions.

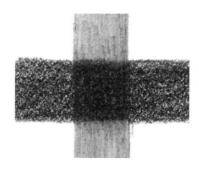

Burnishing It is difficult to achieve a very dark tone with just one graphite pencil, even when using a soft lead. To achieve a dark, flat tone, apply a heavy layer of soft lead followed by a layer of harder lead. The hard lead will push the softer graphite into the tooth of the paper, spreading it evenly. Shown at left is 4H over 4B lead.

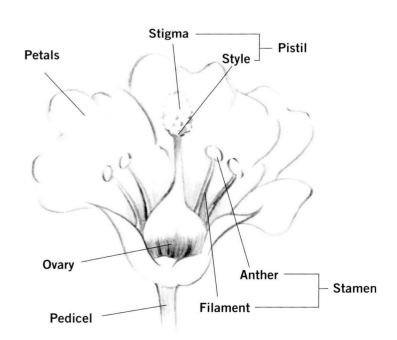

This diagram illustrates the various shapes of the flower parts, which you should study closely before drawing. With effective shading, you can bring out their individual forms.

APPLYING GRAPHITE WITH A BLENDER

Chamois Using a chamois is a great way to apply graphite to a large area. Wrap it around your finger and dip it in saved graphite shavings to create a dark tone, or use what may be already on the chamois to apply a lighter tone.

Stump Stumps are great not only for blending but also for applying graphite. Use an old stump to apply saved graphite shavings to both large and small areas. You can achieve a range of values depending on the amount of graphite on the stump.

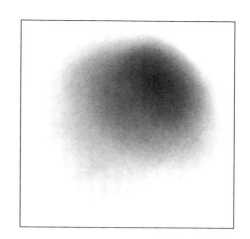

Indenting To preserve fine white lines in a drawing, some artists indent (or incise) the paper before applying tone. Use a stylus to "draw" your white lines; then stroke your pencil over the area and blend. The indentations will remain free of tone.

"Drawing" with an Eraser Use the corner of a block eraser or the end of a stick eraser to "draw" within areas of tone, resulting in light strokes. You can use this technique to recover lights and highlights after blending.

Hatching Hatching is considered one of the simplest forms of shading. Simply apply a series of parallel lines to represent darker tones and shadows. The closer together you place the lines, the darker the shading will appear.

Crosshatching To crosshatch, place layers of parallel lines over each other at varying angles. This results in a "mesh" of tone that gives shaded areas a textured, intricate feel. For an added sense of depth, make the lines follow the curves of your object's surface.

As you shade, follow the angle of the object's surface, and blend to allow the texture to emerge.

BASIC FLOWER SHAPES

Even the most complicated flowers can be developed from simple shapes. Select a flower you wish to draw and study it closely, looking for its overall shape. Sketch the outline of this shape, and begin to look for the other shapes within the flower. Block in the smaller shapes that make up details, such as petals or leaves. Once you've completed this, smooth out your lines and begin the shading process.

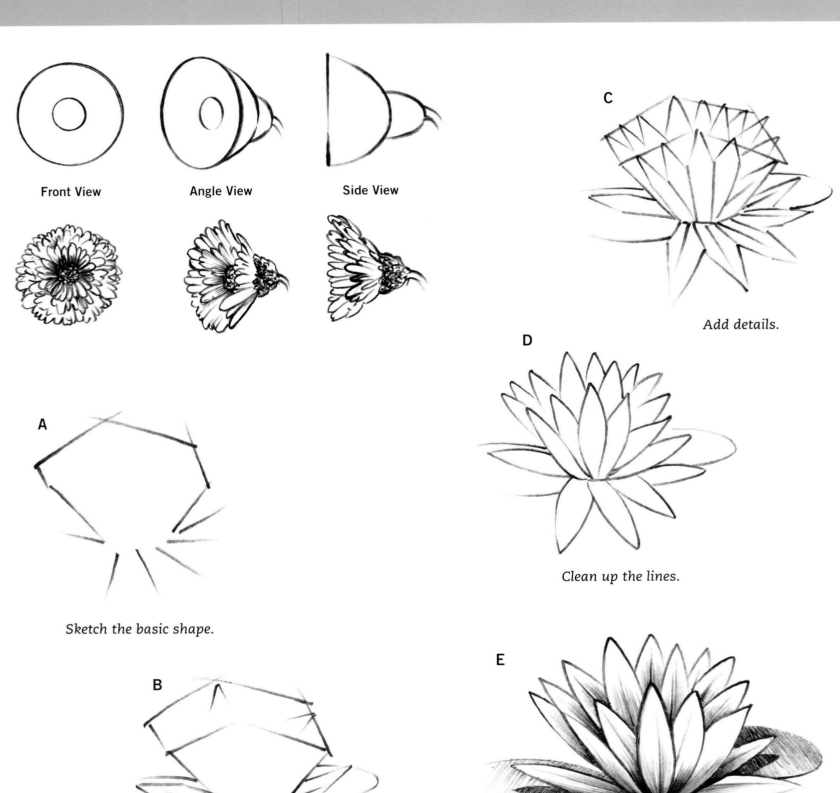

Front View

Angle View

Side View

C

Add details.

A

Sketch the basic shape.

B

Block in smaller shapes.

D

Clean up the lines.

E

Create form by shading.

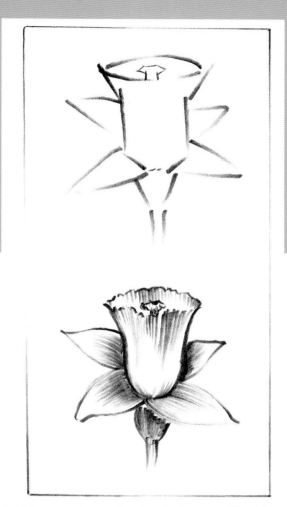

With an HB pencil, sketch the cup-like shape of the flower first; then place the petals and stem, as shown above. Begin developing the form with shading.

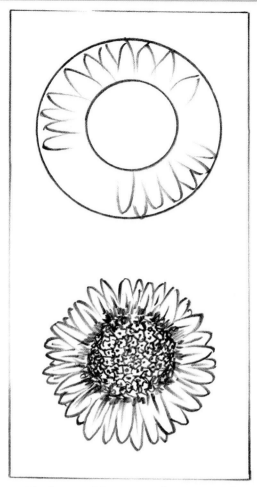

Circles enable you to draw round flowers. Set the size with a large circle, and place a smaller one inside. Using them as a guide, shade details.

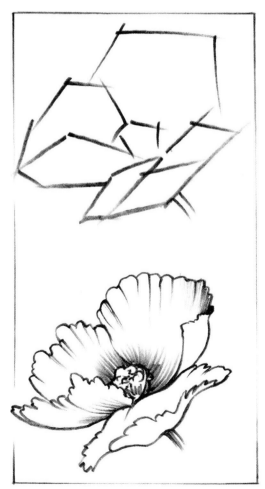

This three-quarter view may seem more difficult to draw, but you can still bring out its basic shapes if you study it carefully. Begin each petal with short lines drawn at the proper angles.

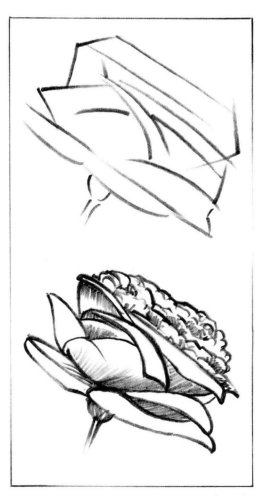

Drawing flowers with many overlapping petals is more involved, but once the basic shapes are sketched in, the details can easily be drawn.

TULIPS

There are several classes of tulips with differently shaped flowers. The one below, known as a parrot tulip, has less of a cup than the tulip to the right and is more complex to draw. Use the layout steps shown here, before drawing the details.

A

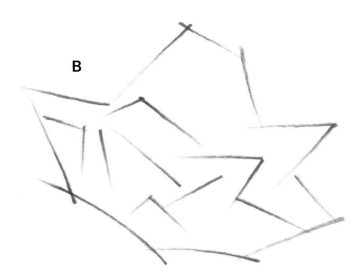

B

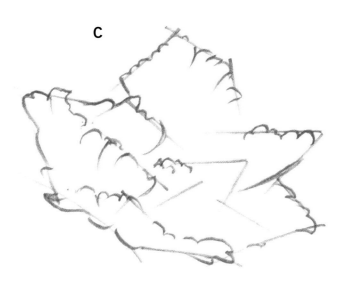

C

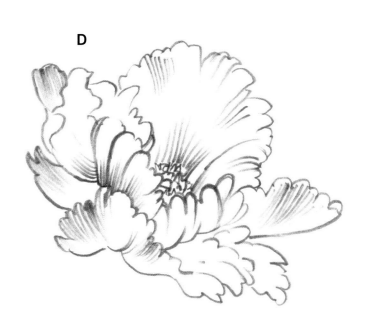

D

For the tulip above, begin step A using straight lines from point to point to capture the major shape of the flower. Add petal angles in step B. Draw in actual petal shapes in step C, and complete the drawing with simple shading.

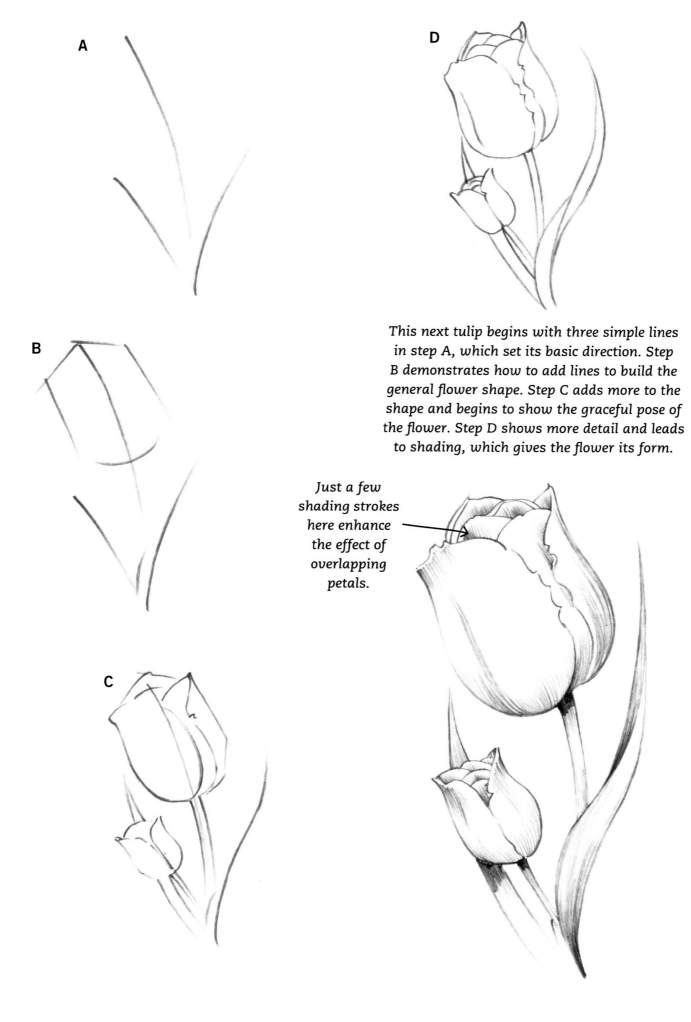

A

B

C

D

This next tulip begins with three simple lines in step A, which set its basic direction. Step B demonstrates how to add lines to build the general flower shape. Step C adds more to the shape and begins to show the graceful pose of the flower. Step D shows more detail and leads to shading, which gives the flower its form.

Just a few shading strokes here enhance the effect of overlapping petals.

MAGNOLIA

The magnolia grandiflora is a large, white, fragrant flower. To make the flower blossom stand out, keep the shading of its petals to a minimum, and shade the leaves underneath darker.

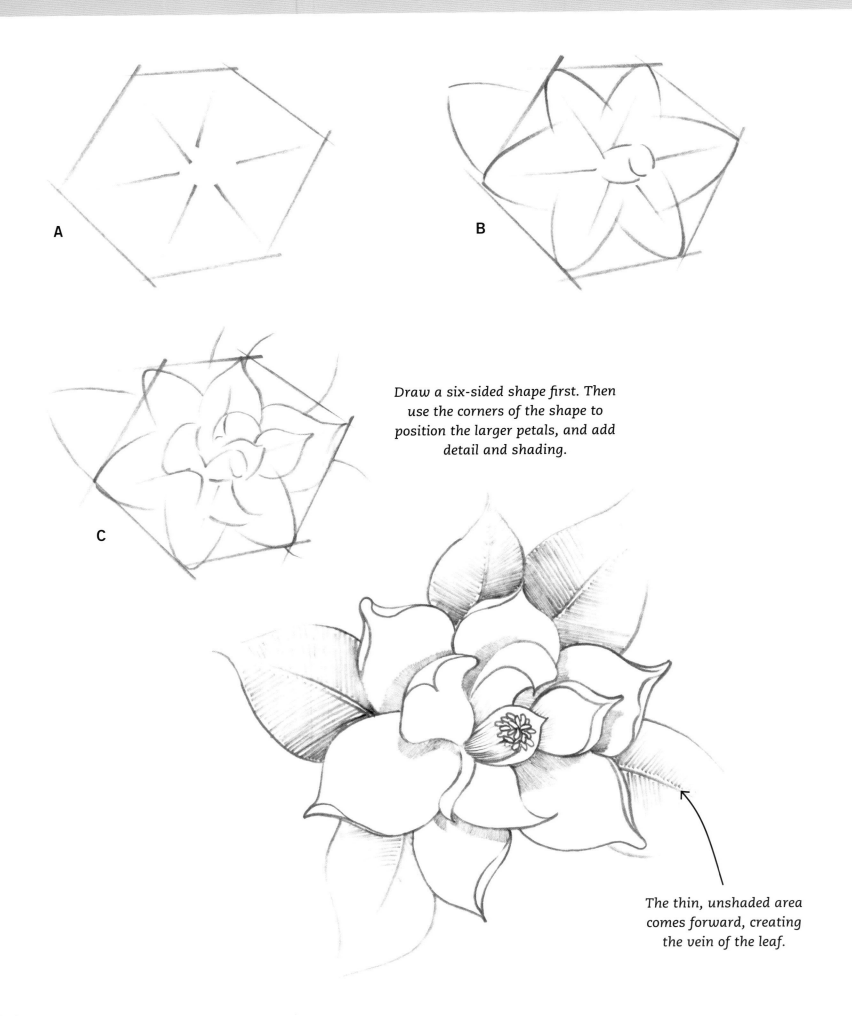

Draw a six-sided shape first. Then use the corners of the shape to position the larger petals, and add detail and shading.

The thin, unshaded area comes forward, creating the vein of the leaf.

DOGWOOD

There are different varieties of dogwood. Below are an East Asian type called a kousa dogwood and an American flowering dogwood. Both of their flowers vary from pure white to delicate pink.

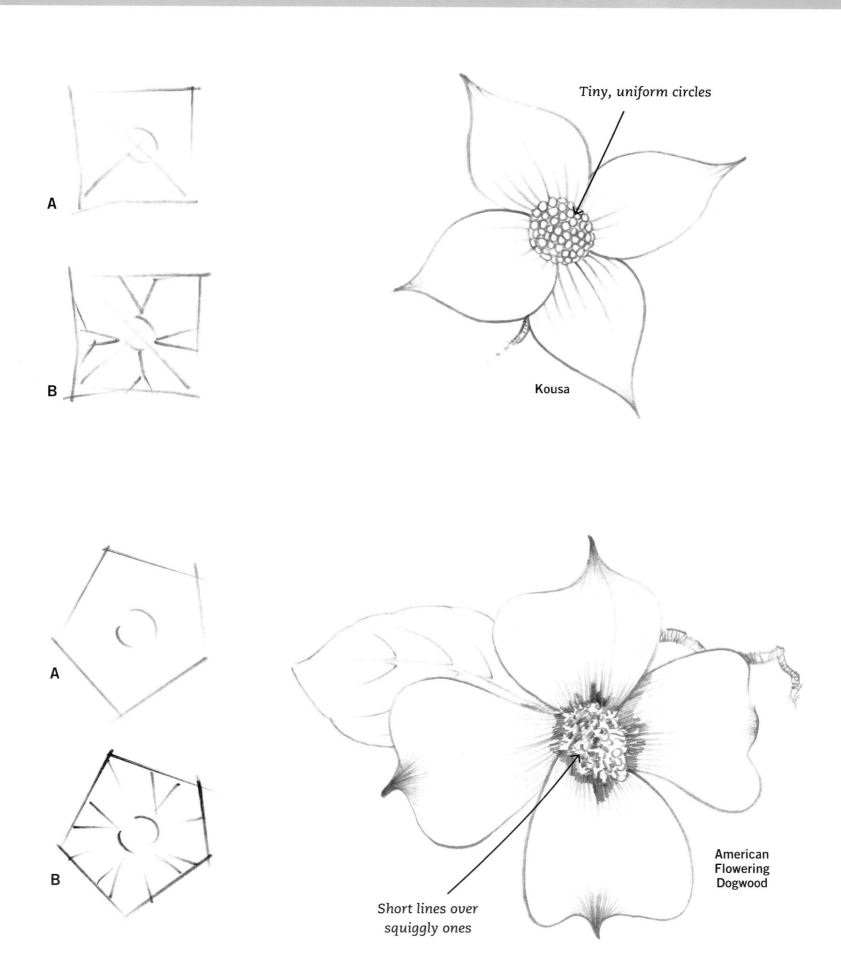

A

B

Tiny, uniform circles

Kousa

A

B

Short lines over squiggly ones

American Flowering Dogwood

REGAL LILY

Lilies are very fragrant, and the plants can grow up to eight feet tall. Use the steps below to develop the flower, which you can attach to the main stem when drawing the entire plant, as shown at the bottom of the opposite page.

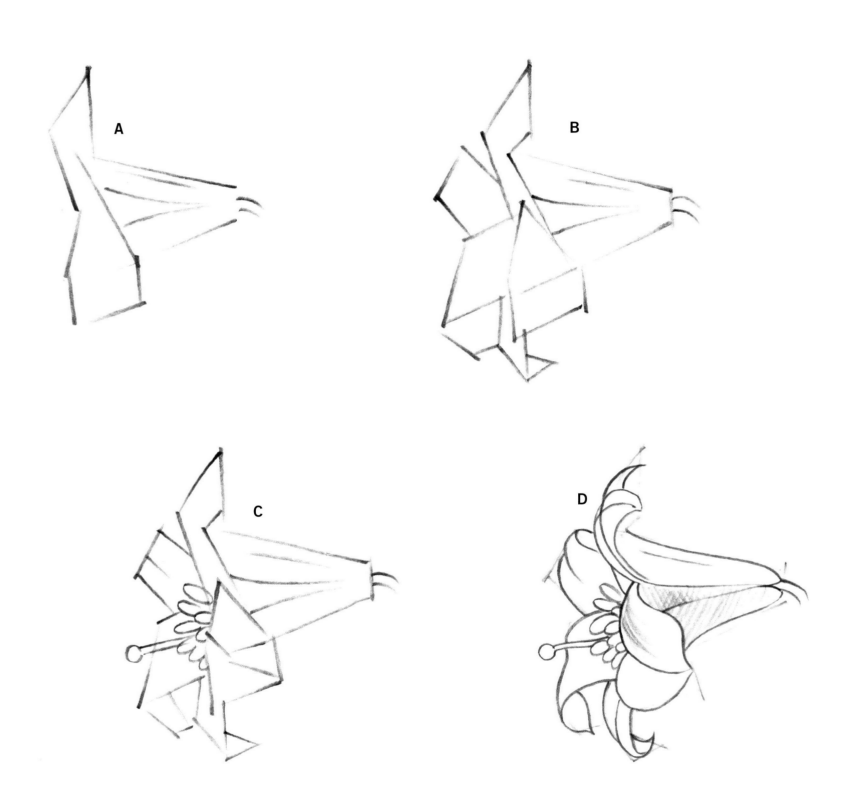

A

B

C

D

A

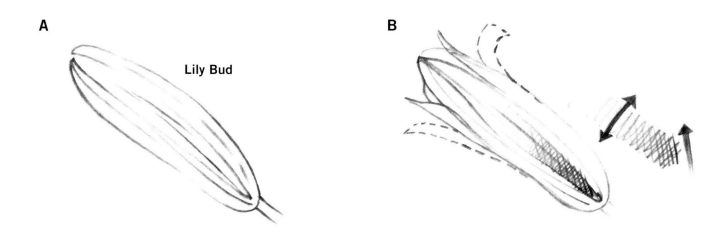

Lily Bud

B

The lily bud in step A above starts out completely closed. Step B illustrates the two angles you should shade to give the bud form. It also shows how to transform the bud so it appears slightly opened. Add these types of buds to your lily plant, paying attention to how they attach to the stems.

Shading lines like these illustrate a technique called "crosshatching" and give the petals form.

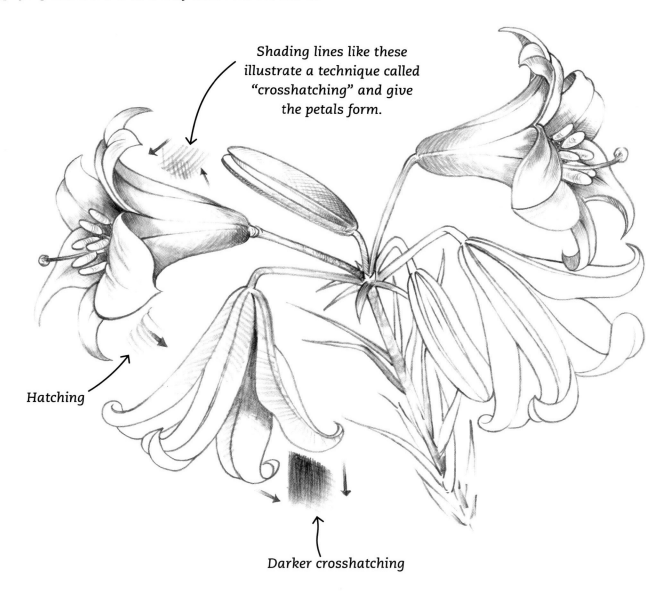

Hatching

Darker crosshatching

DAFFODIL

The flower shown here is a trumpet daffodil, of which there are large- and small-cupped varieties. The horn-like opening of this flower enhances its charm. Follow the steps closely in this exercise and you will end up with a perfect drawing.

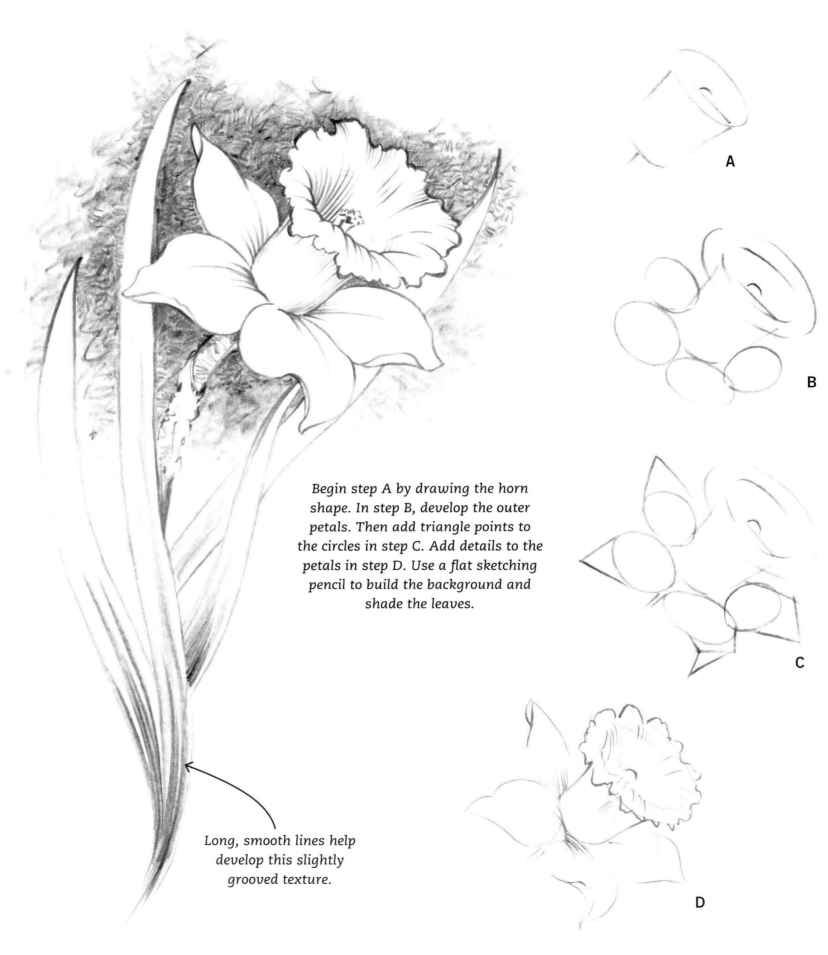

Begin step A by drawing the horn shape. In step B, develop the outer petals. Then add triangle points to the circles in step C. Add details to the petals in step D. Use a flat sketching pencil to build the background and shade the leaves.

Long, smooth lines help develop this slightly grooved texture.

A

B

C

D

CARNATION

Carnation varieties range from deep red and bicolored to white. They are showy and easy to grow in most gardens. They are also fun and challenging to draw because of their many overlaying petals. Shade them solid, variegated, or with a light or dark edge at the end of each petal.

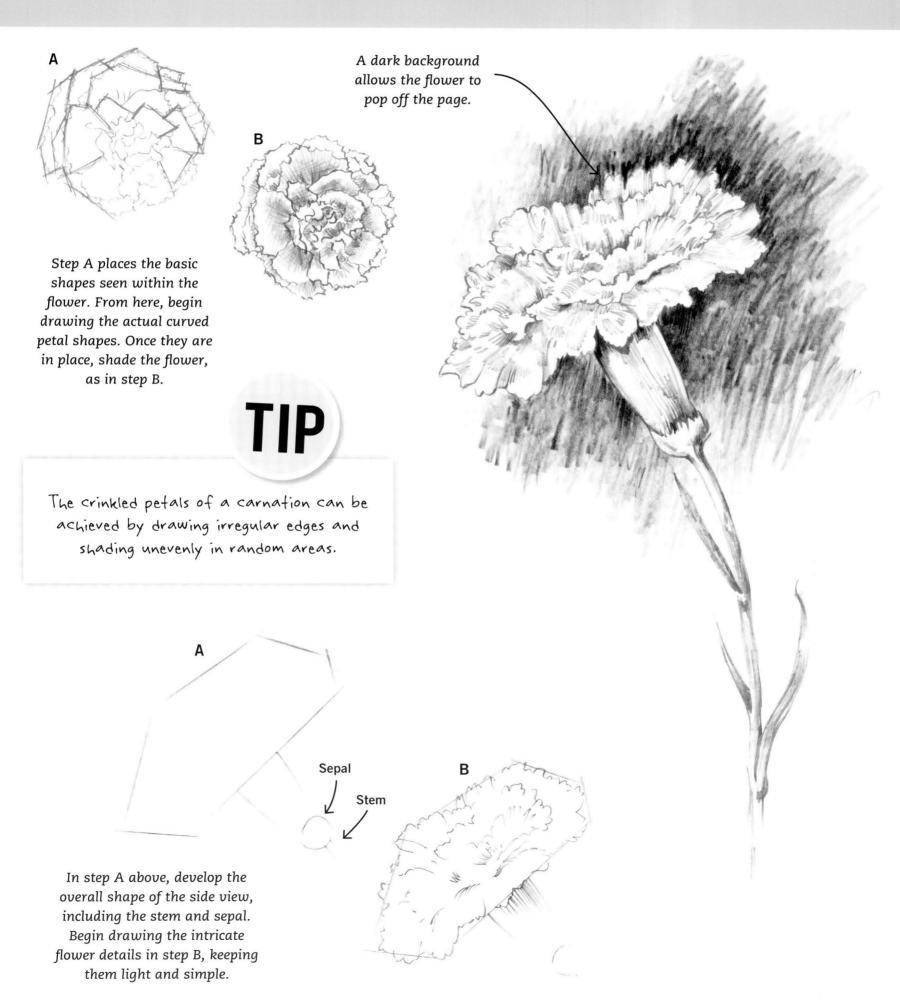

A

B

A dark background allows the flower to pop off the page.

Step A places the basic shapes seen within the flower. From here, begin drawing the actual curved petal shapes. Once they are in place, shade the flower, as in step B.

TIP

The crinkled petals of a carnation can be achieved by drawing irregular edges and shading unevenly in random areas.

A

Sepal

Stem

B

In step A above, develop the overall shape of the side view, including the stem and sepal. Begin drawing the intricate flower details in step B, keeping them light and simple.

ENGLISH WALLFLOWER

These velvety orange, red, and yellow flowers are found on bushy plants that can grow up to two feet high. Several types range from dwarf to tall. Some varieties are even bicolored with darker tips.

Follow the steps closely, laying down the four large petals inside your block-in shape with straight lines. Start smoothing out the lines into the petal edges and filling in details; then lightly shade. Sometimes simple renderings like this present your subject best.

Draw your preliminary lines lightly so they are easy to erase later.

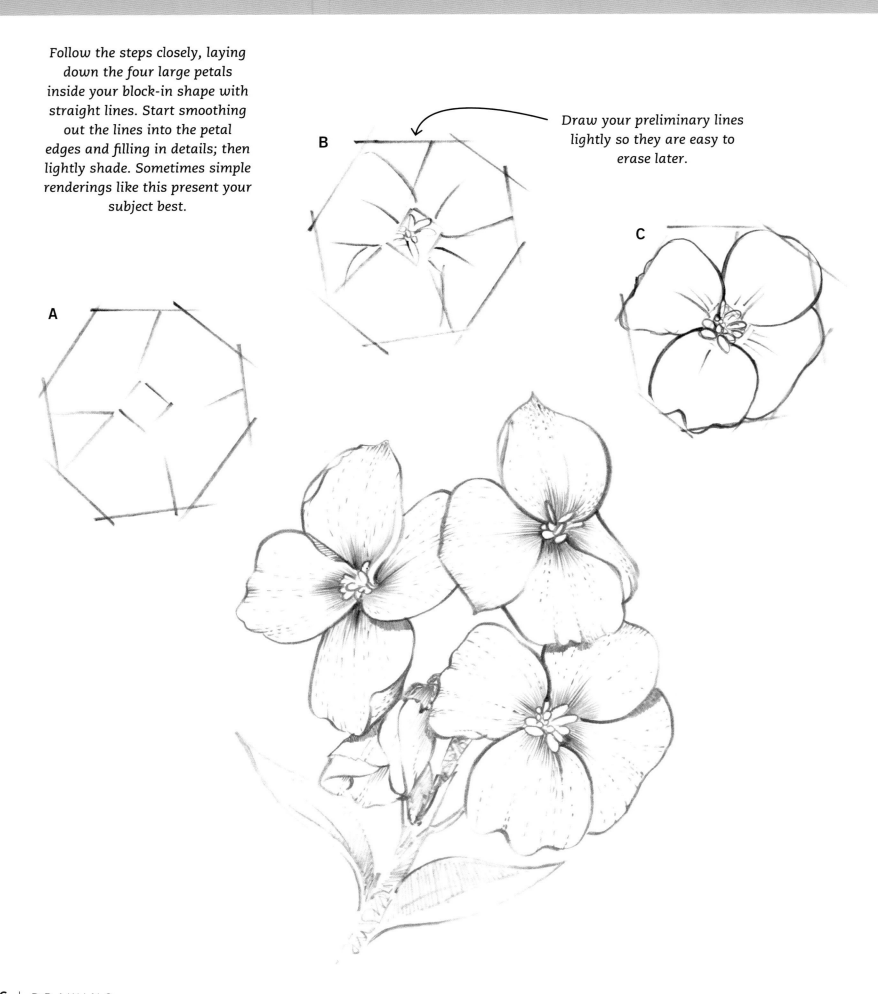

BEGONIA

There are single- and double-flowered begonias. The double-flowered variety is a bit more difficult to draw. Don't rush this flower, because it's easy to lose your place. Study each step before drawing the flower yourself.

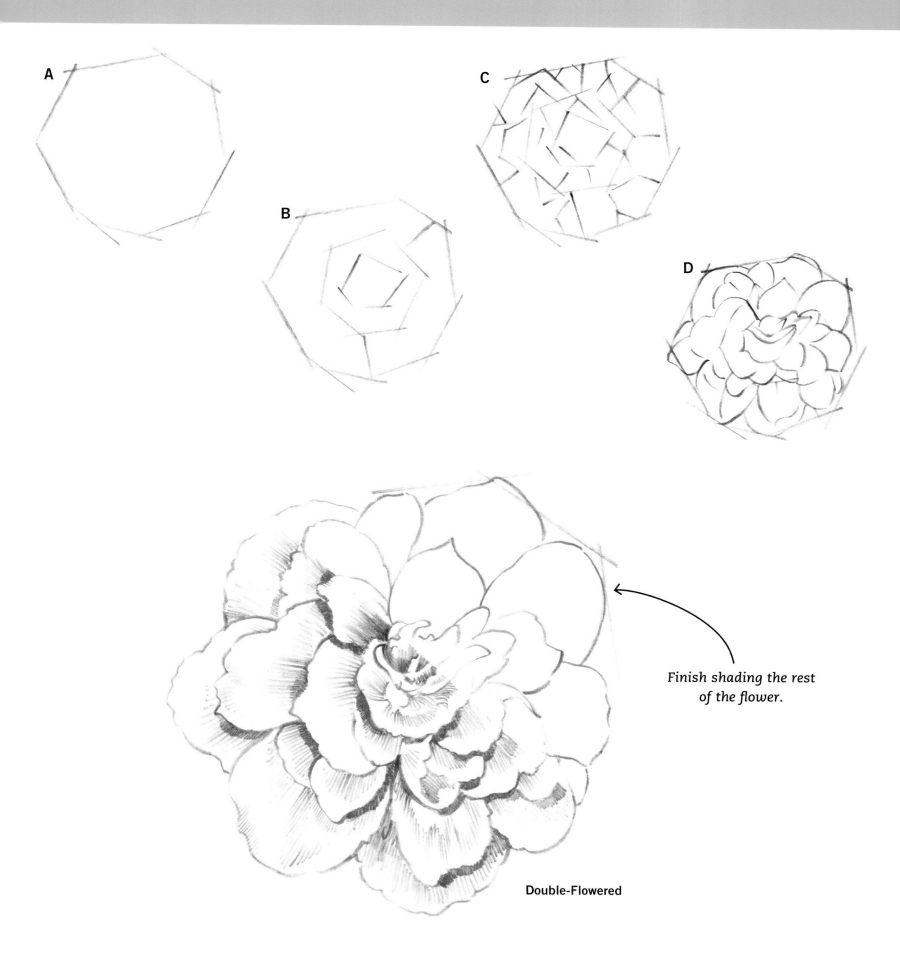

A

B

C

D

Finish shading the rest of the flower.

Double-Flowered

POPPY

The beautiful California poppy grows in a variety of colors from deep orange to pale yellow. The blossoms have a silky texture, and the flower spreads about two inches wide.

Use the diagram below to draw the whole plant, and follow the steps for the individual flower.

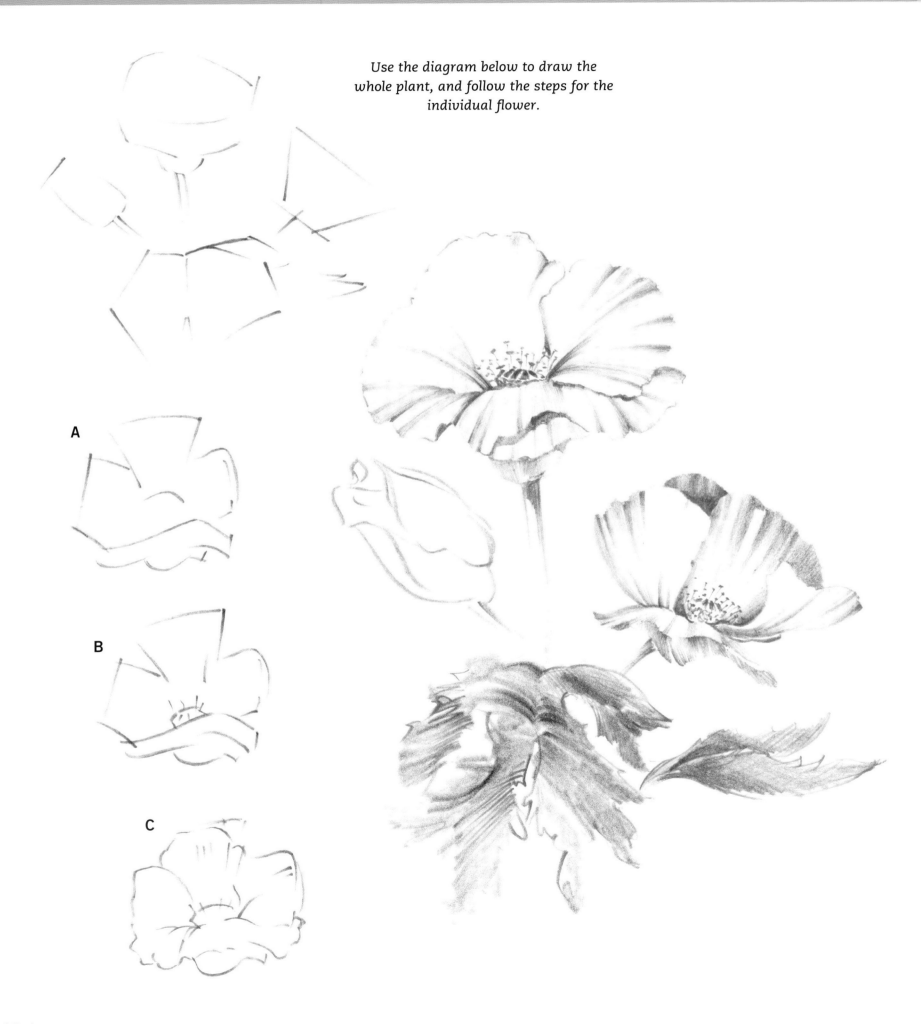

A

B

C

PANSY

Pansies grow in many color combinations. Sometimes these combinations resemble faces, almost as though they have expressions.

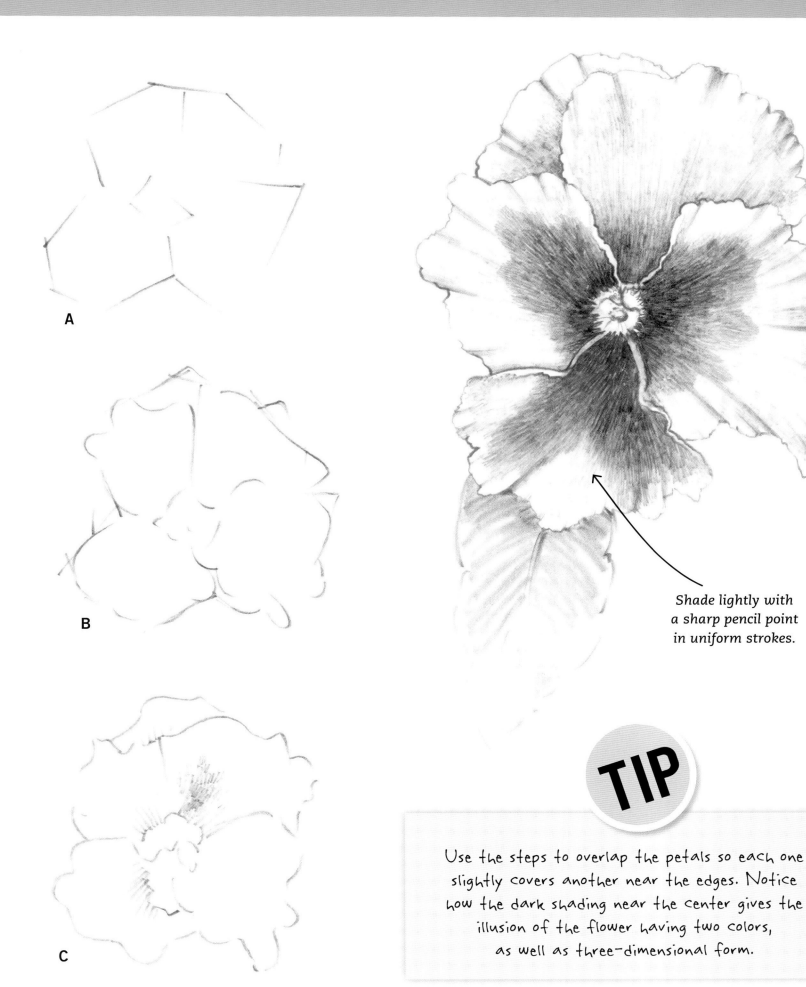

A

B

C

Shade lightly with a sharp pencil point in uniform strokes.

TIP

Use the steps to overlap the petals so each one slightly covers another near the edges. Notice how the dark shading near the center gives the illusion of the flower having two colors, as well as three-dimensional form.

DENDROBIUM

The dendrobium is an orchid variety native to tropical climates. They have slender stems up to two feet long. Flowers grow 2½ to 3½ inches across. Colors range from blends of mauve, containing deeper-colored veins, to maroon and pale purple.

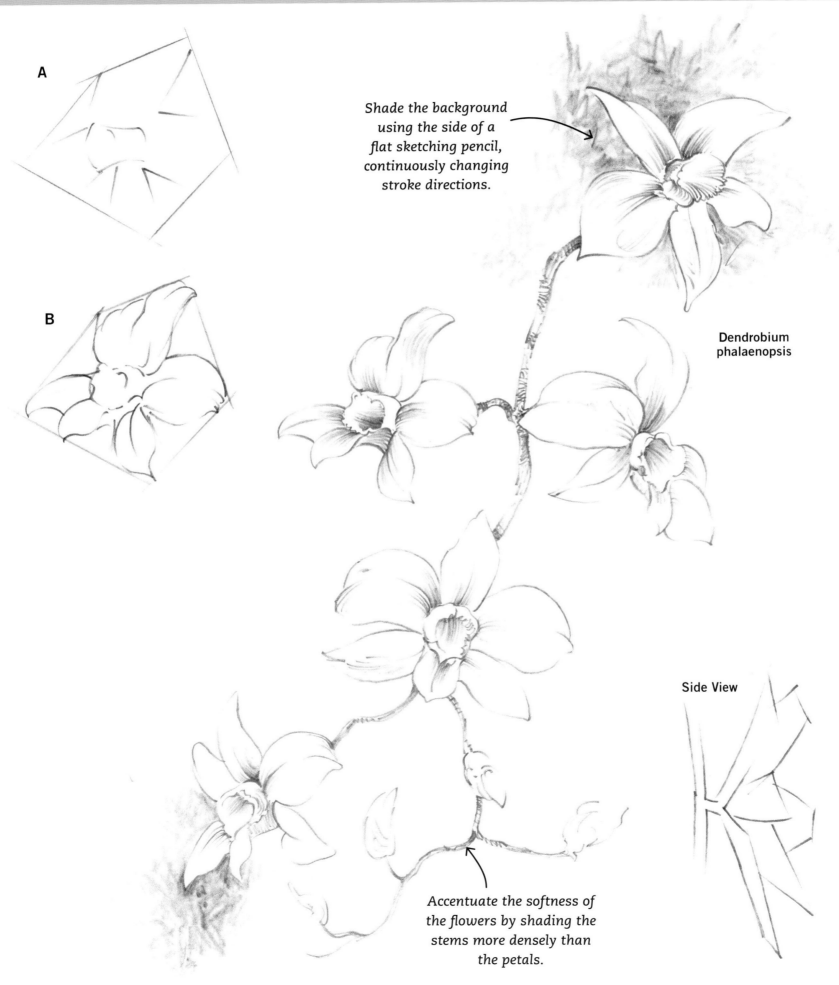

A

B

Shade the background using the side of a flat sketching pencil, continuously changing stroke directions.

Dendrobium phalaenopsis

Side View

Accentuate the softness of the flowers by shading the stems more densely than the petals.

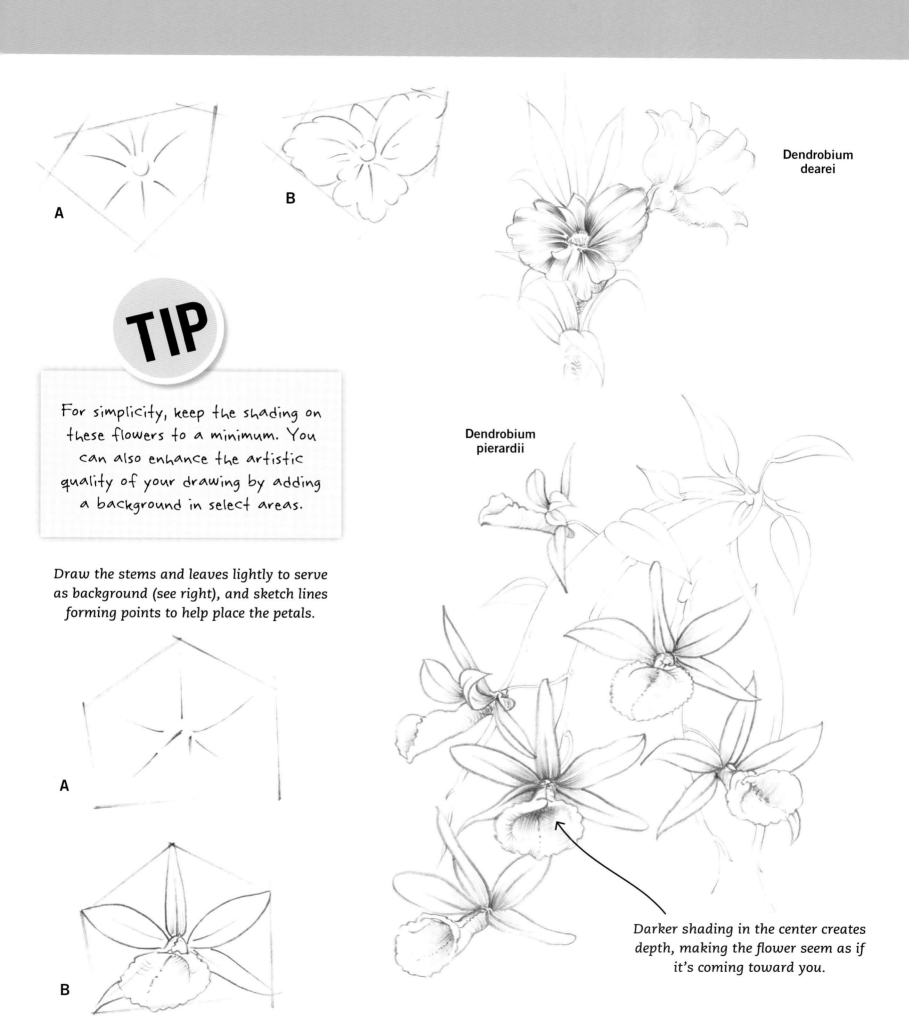

A

B

TIP

For simplicity, keep the shading on these flowers to a minimum. You can also enhance the artistic quality of your drawing by adding a background in select areas.

Draw the stems and leaves lightly to serve as background (see right), and sketch lines forming points to help place the petals.

A

B

Dendrobium
dearei

Dendrobium
pierardii

Darker shading in the center creates depth, making the flower seem as if it's coming toward you.

PRIMROSE

There are many primrose varieties with a wide range of colors. This exercise demonstrates how to draw a number of flowers and buds together. Take your time when placing them.

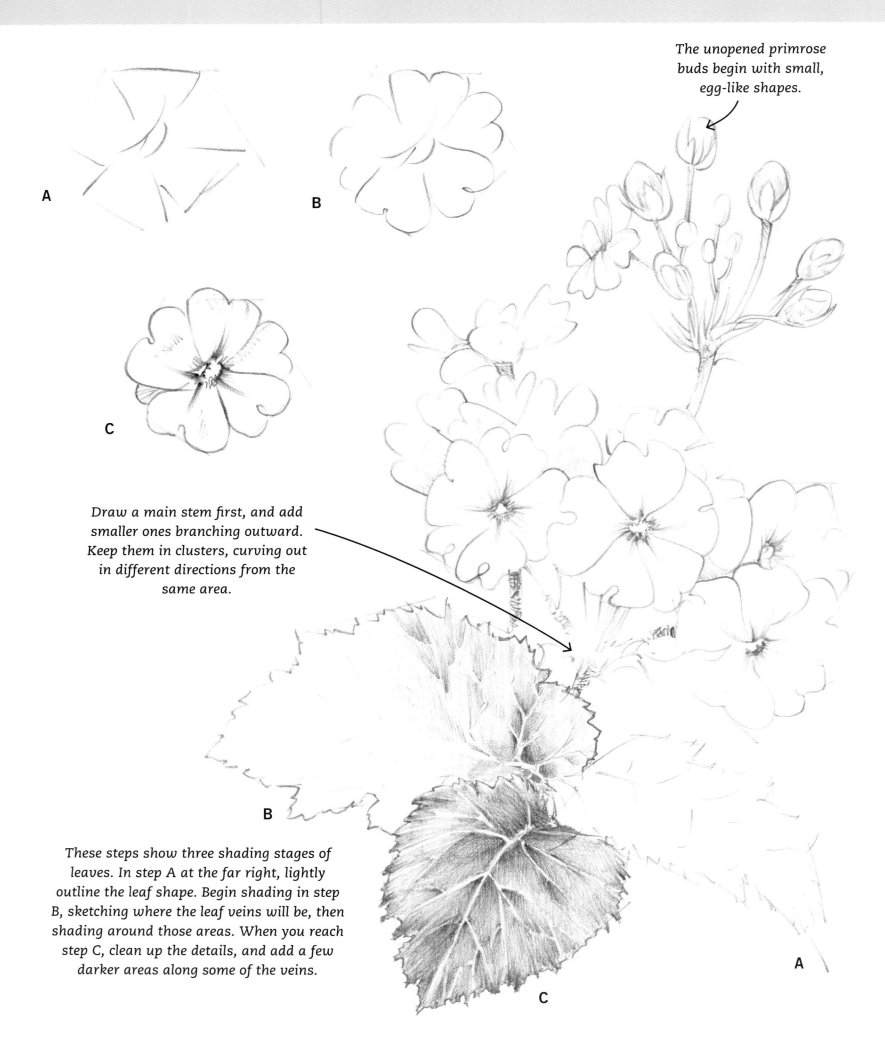

The unopened primrose buds begin with small, egg-like shapes.

Draw a main stem first, and add smaller ones branching outward. Keep them in clusters, curving out in different directions from the same area.

These steps show three shading stages of leaves. In step A at the far right, lightly outline the leaf shape. Begin shading in step B, sketching where the leaf veins will be, then shading around those areas. When you reach step C, clean up the details, and add a few darker areas along some of the veins.

HIBISCUS

Hibiscus grow in single- and double-flowered varieties, and their colors include whites, oranges, pinks, and reds—even blues and purples. Some are multi- or bicolored.

Step A shows the overall mass, petal direction, and basic center of the flower. Before shading the petals in step B, study where the shading falls and how it gives the petals a slightly rippled effect. Add the details of the flower center, and block in the stem and leaves.

A

B
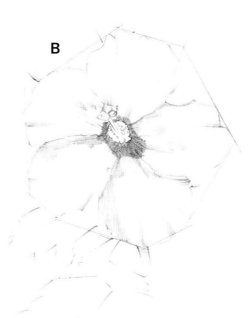

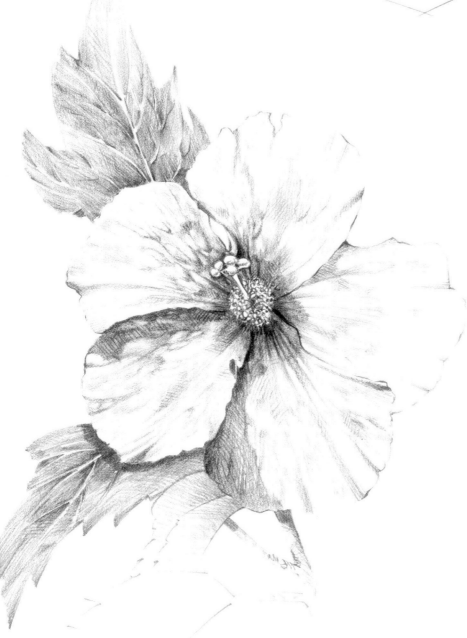

TIP

To add variety to an arrangement, try drawing a few buds, and attach them to stem branches around your drawing.

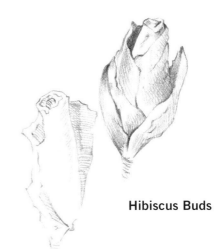

Hibiscus Buds

FUCHSIA

Fuchsias present beautiful color variety, including greens, reds, and purples. This exercise should be drawn on vellum-finish (rough) Bristol board to enhance the irregular texture of the flowers.

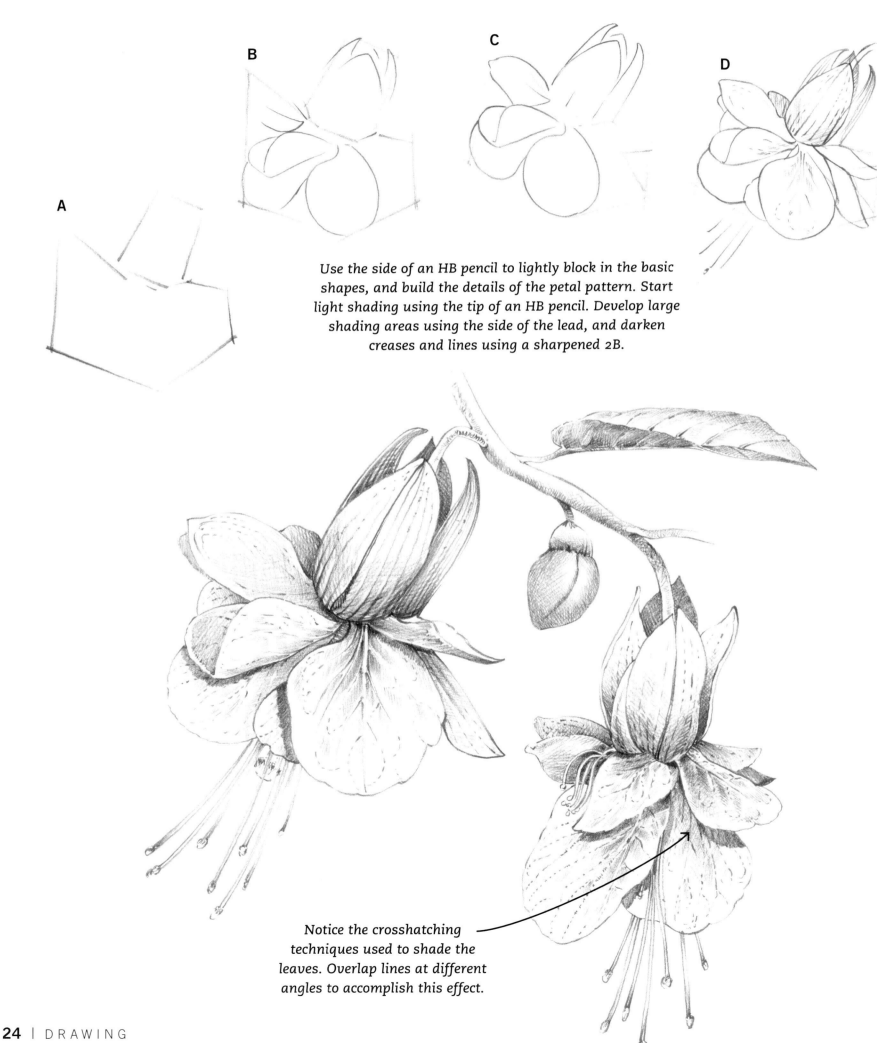

Use the side of an HB pencil to lightly block in the basic shapes, and build the details of the petal pattern. Start light shading using the tip of an HB pencil. Develop large shading areas using the side of the lead, and darken creases and lines using a sharpened 2B.

Notice the crosshatching techniques used to shade the leaves. Overlap lines at different angles to accomplish this effect.

PEONY

Peonies also grow in single- and double-flowered varieties. They are a showy flower and make fine subjects for flower drawings.

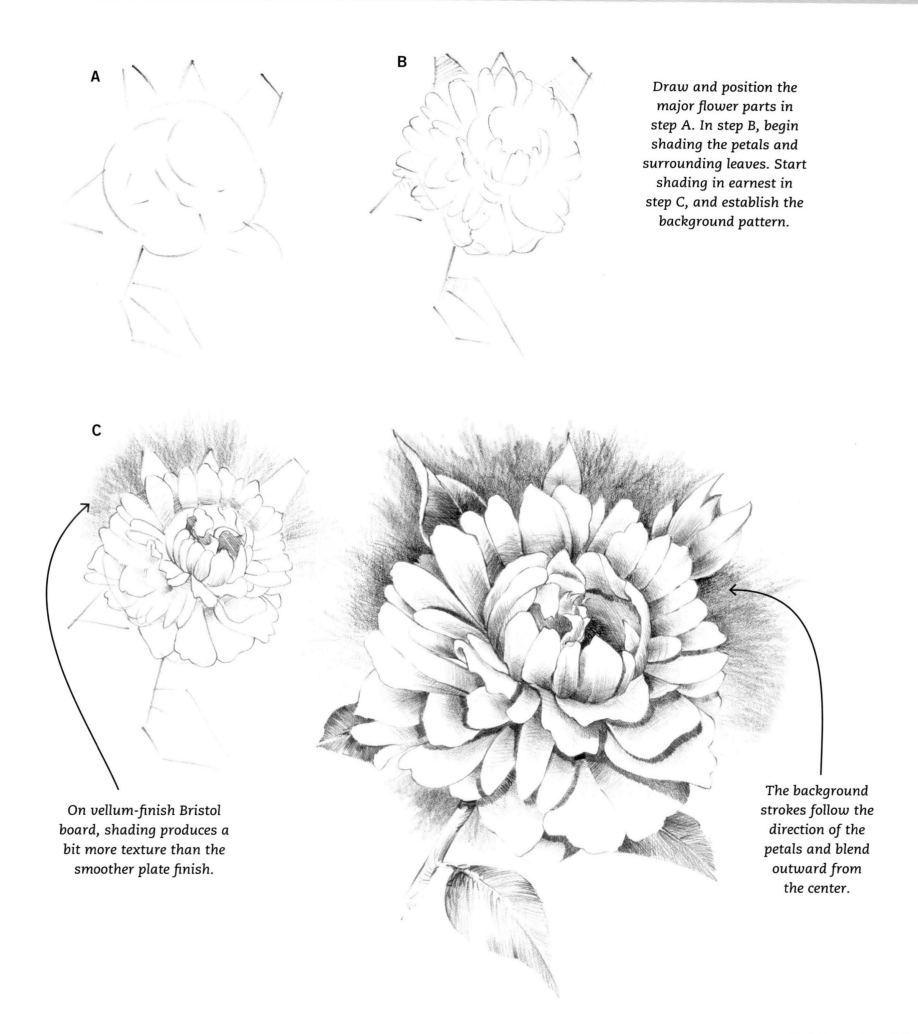

A

B

Draw and position the major flower parts in step A. In step B, begin shading the petals and surrounding leaves. Start shading in earnest in step C, and establish the background pattern.

C

On vellum-finish Bristol board, shading produces a bit more texture than the smoother plate finish.

The background strokes follow the direction of the petals and blend outward from the center.

FOXGLOVE

Foxgloves are tall, erect, biennial plants. Their flowers are long and tubular. The white, yellow, rose, or purple flowers usually contain a dotted pattern on the inside.

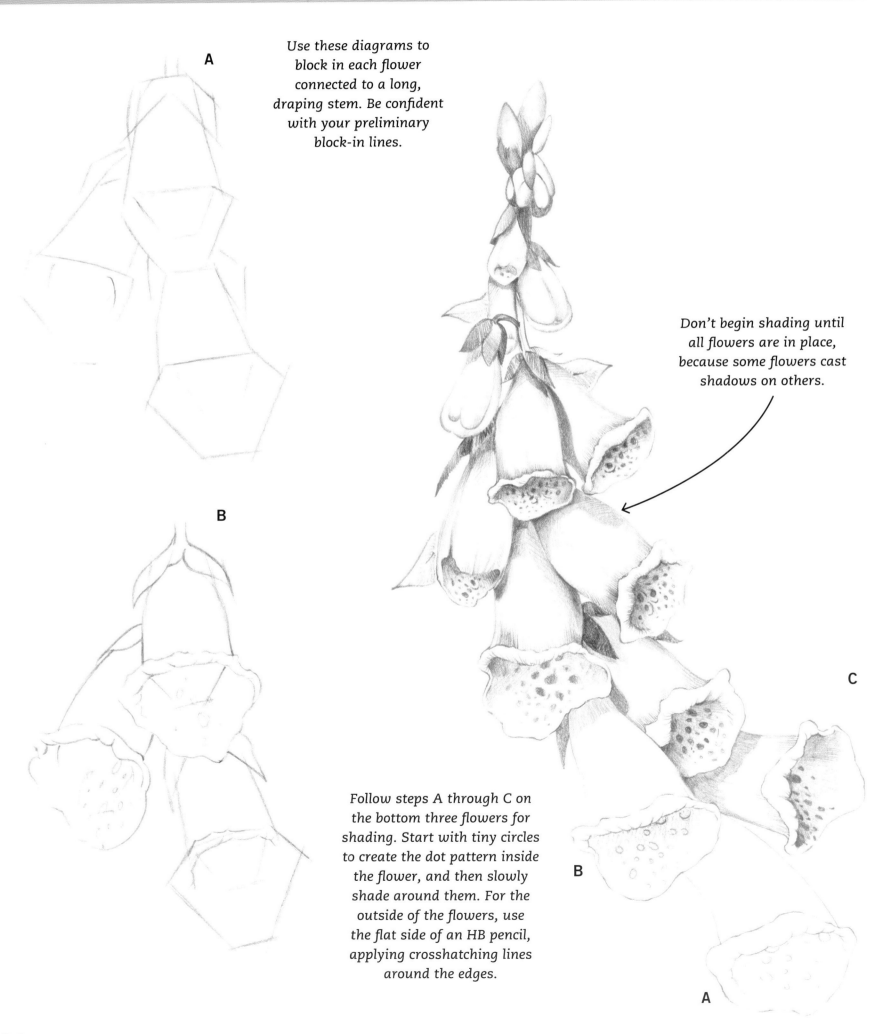

A

Use these diagrams to block in each flower connected to a long, draping stem. Be confident with your preliminary block-in lines.

Don't begin shading until all flowers are in place, because some flowers cast shadows on others.

B

Follow steps A through C on the bottom three flowers for shading. Start with tiny circles to create the dot pattern inside the flower, and then slowly shade around them. For the outside of the flowers, use the flat side of an HB pencil, applying crosshatching lines around the edges.

C

B

A

COLUMBINE

The columbine is an unusual flower with long protrusions knows as spurs. These spurs are important to butterflies and hummingbirds because each tip contains a drop of nectar.

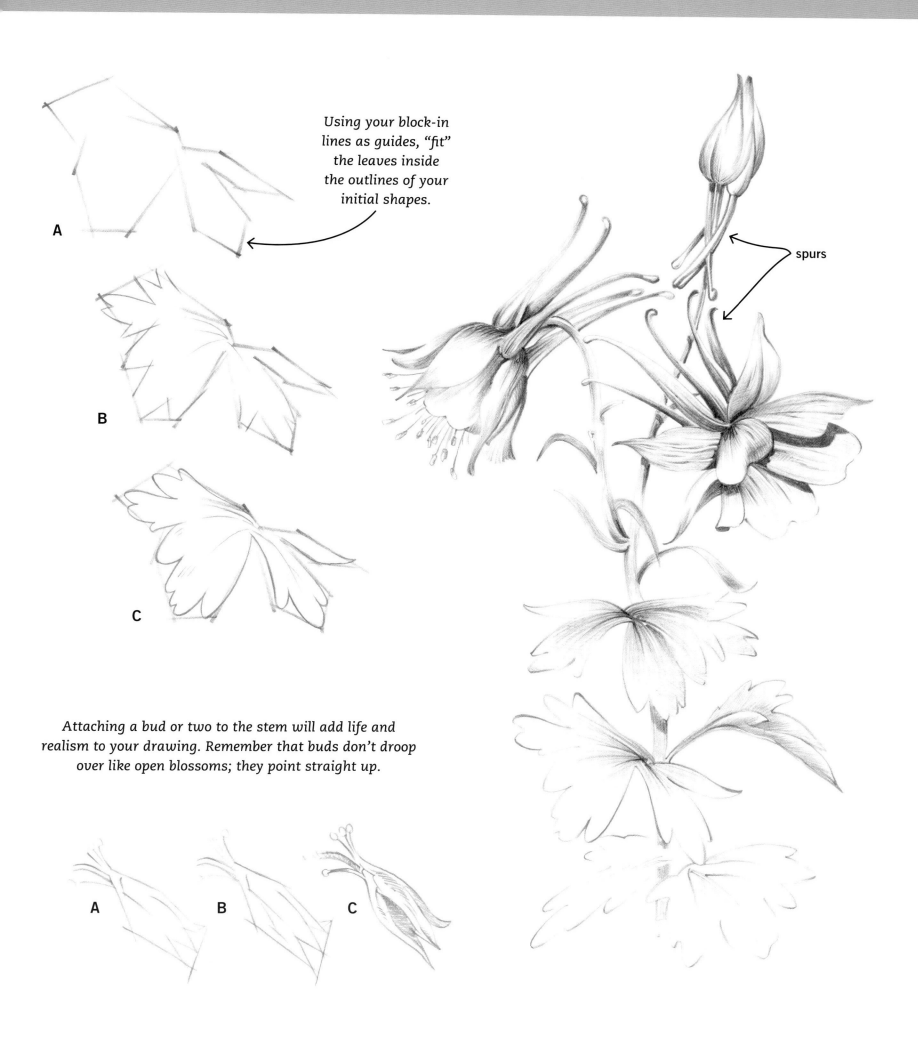

Using your block-in lines as guides, "fit" the leaves inside the outlines of your initial shapes.

A

B

C

spurs

Attaching a bud or two to the stem will add life and realism to your drawing. Remember that buds don't droop over like open blossoms; they point straight up.

A B C

HYBRID TEA ROSE

Hybrid tea roses have large blossoms with greatly varying colors. When drawing rose petals, think of each fitting into its own place in the overall shape; this helps position them correctly. Begin lightly with an HB pencil, and use plate-finish Bristol board.

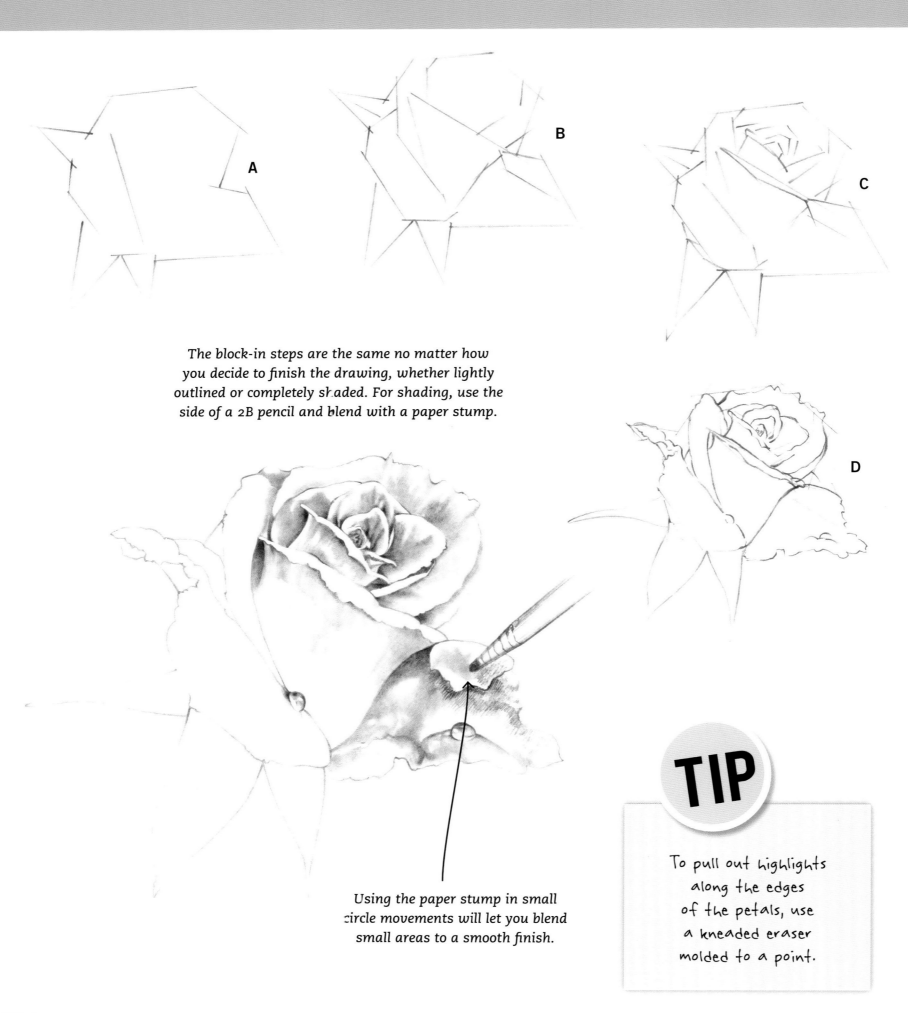

The block-in steps are the same no matter how you decide to finish the drawing, whether lightly outlined or completely shaded. For shading, use the side of a 2B pencil and blend with a paper stump.

Using the paper stump in small circle movements will let you blend small areas to a smooth finish.

TIP

To pull out highlights along the edges of the petals, use a kneaded eraser molded to a point.

FLORIBUNDA ROSE

Floribunda roses usually flower more freely than hybrid tea roses and grow in groups of blossoms. The petal arrangement in these roses is involved, but by studying it closely, you'll see an overlapping, swirling pattern.

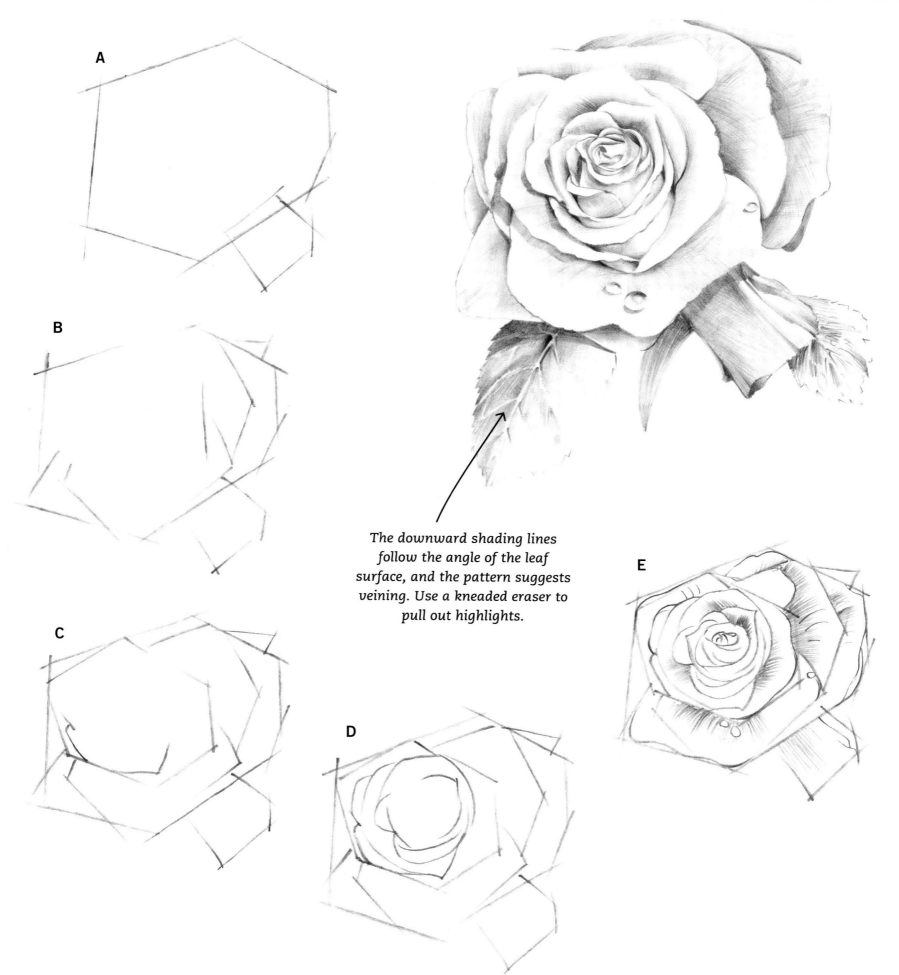

A

B

C

D

E

The downward shading lines follow the angle of the leaf surface, and the pattern suggests veining. Use a kneaded eraser to pull out highlights.

THISTLE

Of the many thistle species, the one shown here is the *Cirsium muticum.* It's a popular, purple-flowered specimen that can be found in fields and low-lying pastures. The prickly sides are a drawing challenge because you must render a wide range of surface textures. The side of the flower is prickly, while the flower is soft and delicate.

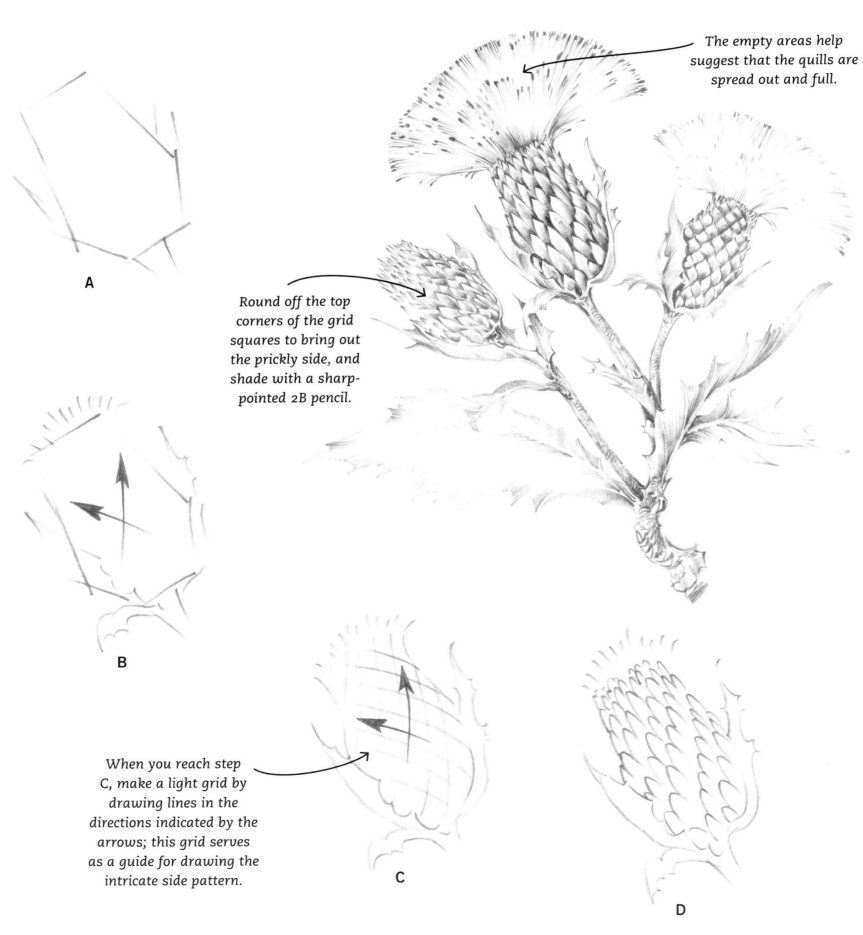

The empty areas help suggest that the quills are spread out and full.

Round off the top corners of the grid squares to bring out the prickly side, and shade with a sharp-pointed 2B pencil.

A

B

When you reach step C, make a light grid by drawing lines in the directions indicated by the arrows; this grid serves as a guide for drawing the intricate side pattern.

C

D

BLEEDING HEART

The bleeding heart blooms beautifully in arching sprays and produces pink or white blossoms. The flowers are locket-shaped and dangle from curved stems like a necklace.

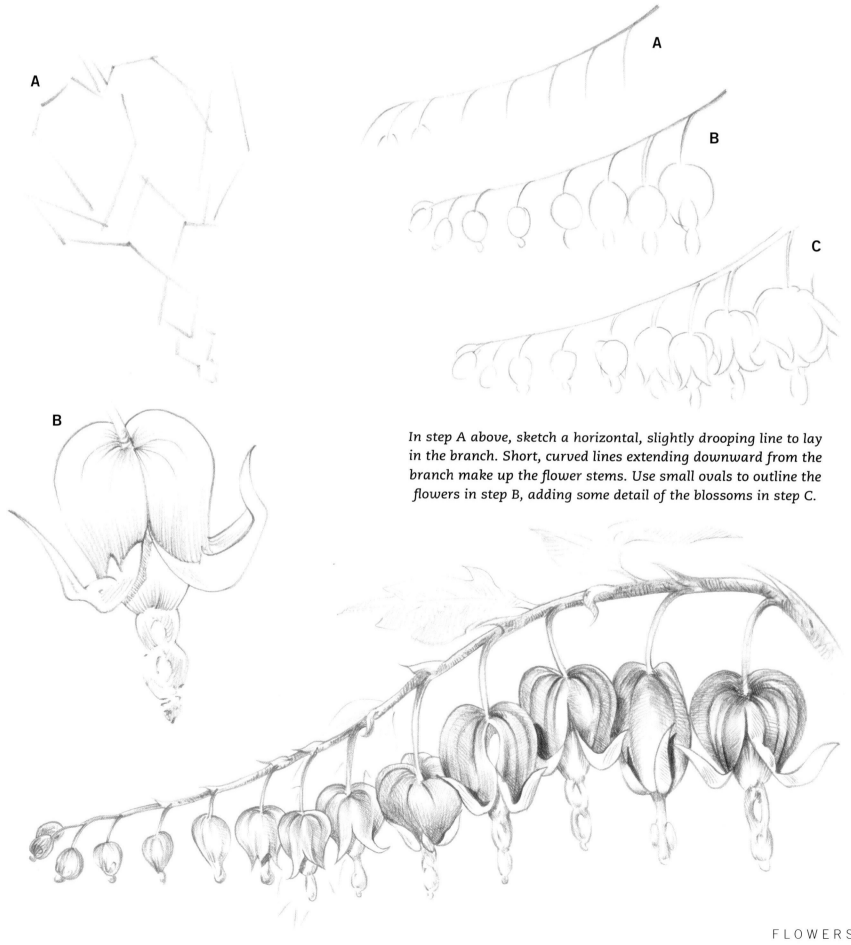

A

A

B

C

B

In step A above, sketch a horizontal, slightly drooping line to lay in the branch. Short, curved lines extending downward from the branch make up the flower stems. Use small ovals to outline the flowers in step B, adding some detail of the blossoms in step C.

GLADIOLUS

Gladiolus can grow to a height of two to six feet, and their flowers range from two to six inches across. Petals can be smooth, flaring, wavy, or ruffled.

Block in the flower and begin shading using the side of the HB, blending with a paper stump. Draw subtle texture lines using the sharp point of an HB, filling in shadows with a 2B. Finally, lift out highlights with a kneaded eraser.

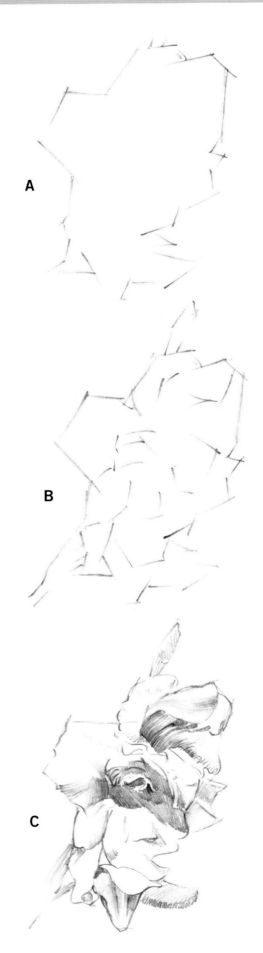

A

B

C

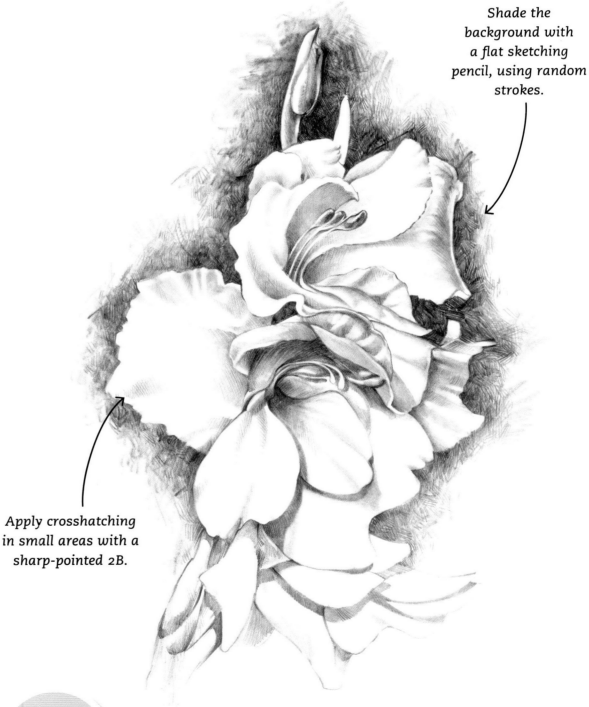

Shade the background with a flat sketching pencil, using random strokes.

Apply crosshatching in small areas with a sharp-pointed 2B.

TIP Every block-in line is important, especially when drawing closely overlapped petals. Put your observation skills to the test!

CHRYSANTHEMUMS

The pompon chrysanthemum produces flowers one to two inches across and are more button-like than the larger, more globular types on the following pages.

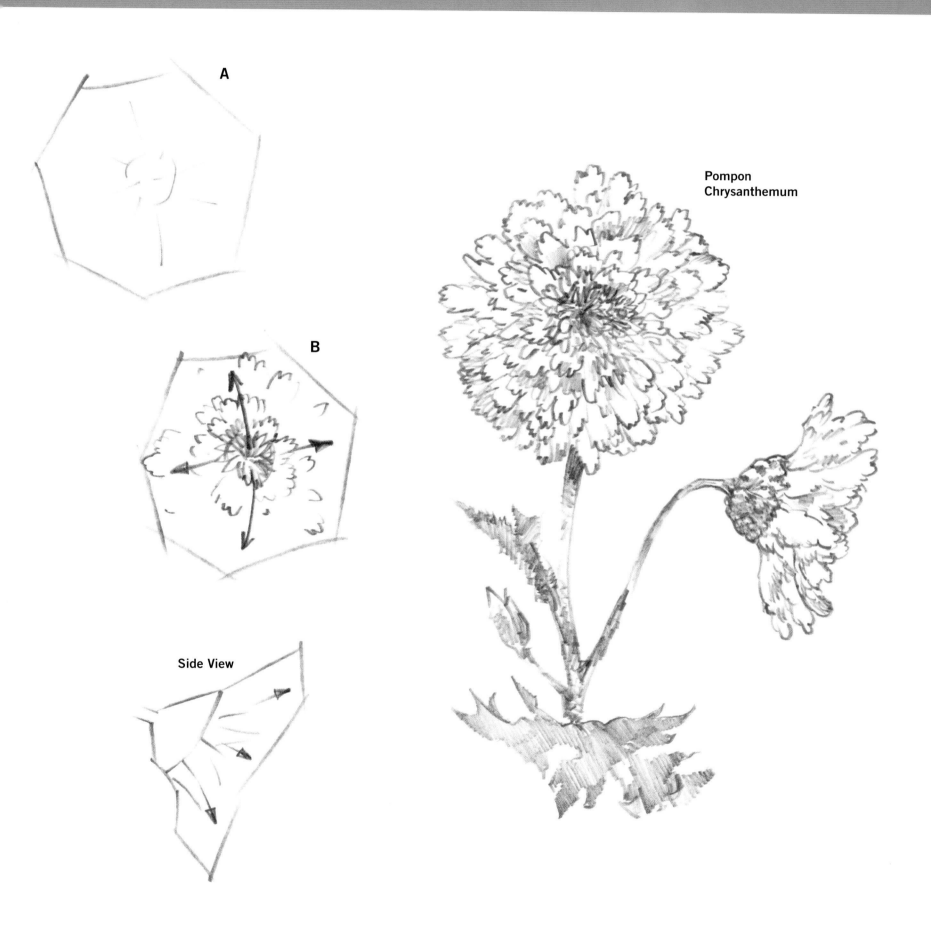

A

B

Pompon
Chrysanthemum

Side View

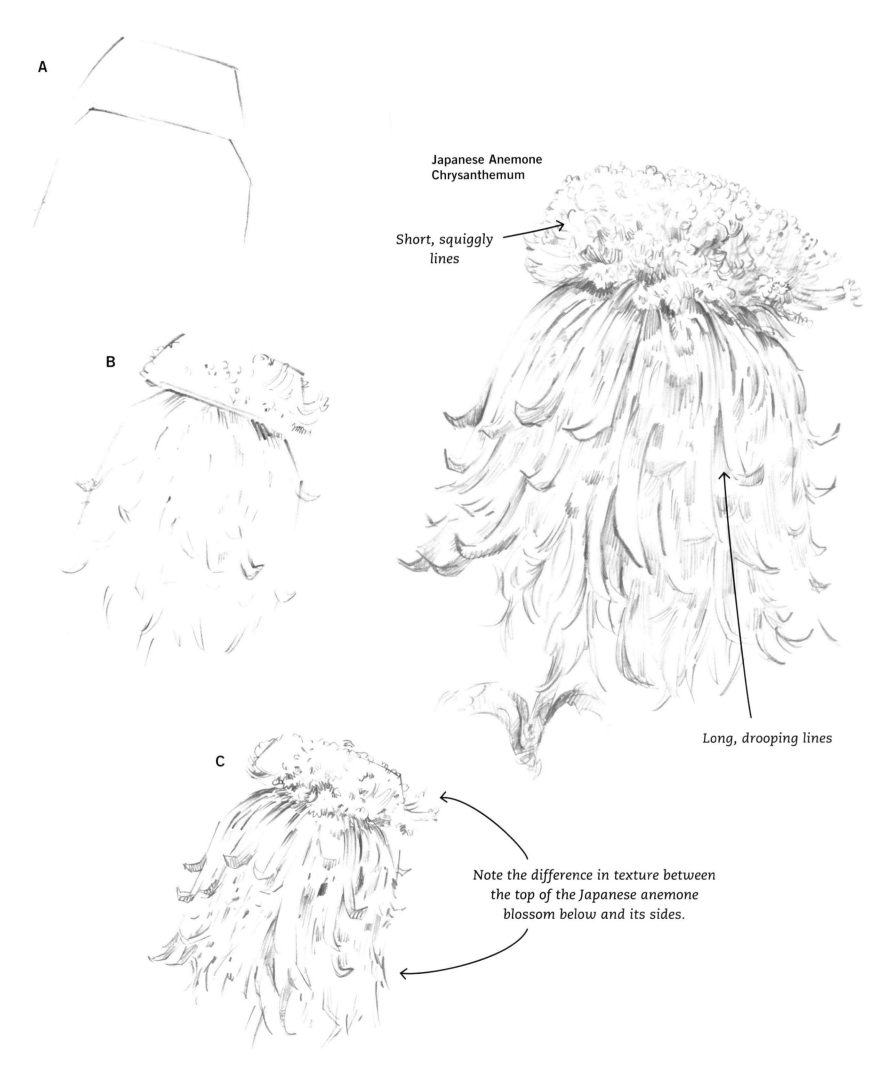

A

Japanese Anemone
Chrysanthemum

*Short, squiggly
lines*

B

Long, drooping lines

C

*Note the difference in texture between
the top of the Japanese anemone
blossom below and its sides.*

Develop the drawing outline with a 2B pencil; then add an interesting background using a flat sketch pencil in random strokes and varying pressures. Follow the arrows as shown in step A when developing the petals. Work from the center outward, allowing each new petal to be overlapped by the previous one. Step B shows most of the petals in place.

B

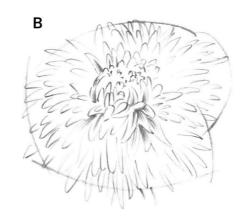

Border Chrysanthemum

A

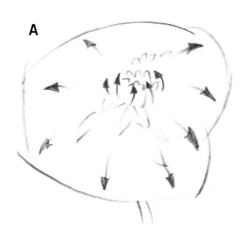

The unopened chrysanthemum bud resembles a miniature pumpkin.

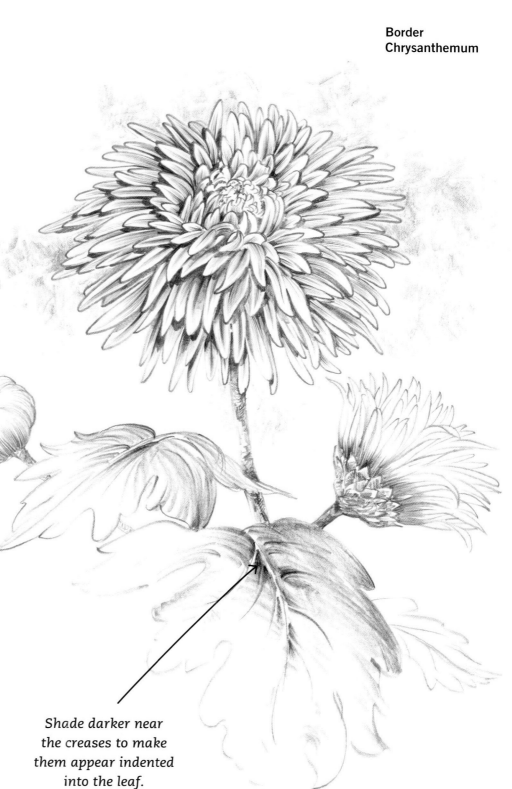

To avoid the drawing having an unfinished appearance, pay equal attention to each petal as you draw and shade.

Shade darker near the creases to make them appear indented into the leaf.

ASTERS

These three types of asters should be drawn on plate-finish Bristol board using both HB and 2B pencils. Note differences in the overall formation of each one. Use the block-in methods you've learned in the previous exercises before shading.

Comet China Aster

A

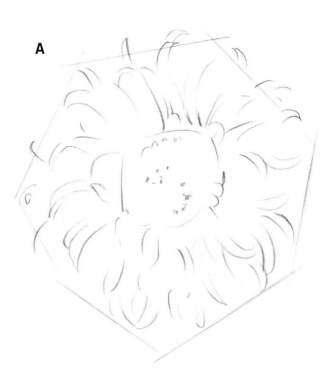

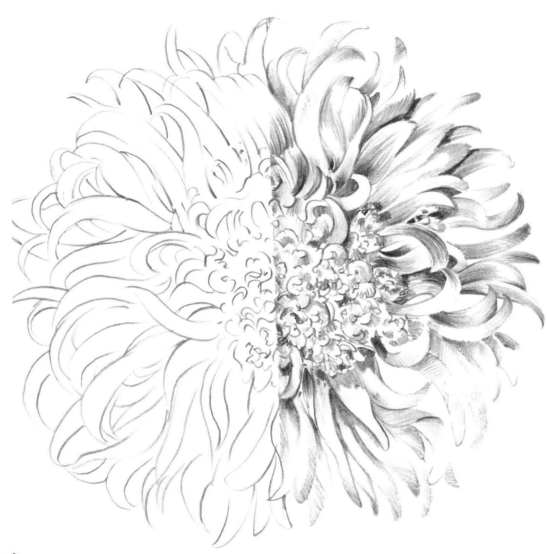

The left side of the drawing on the right shows careful crafting and placement of individual petals. While this is time-consuming, the overall result of this polished technique is worth the effort. Once the drawing is finished, shade the flower using smooth lines, as shown on the right side.

Quilled China Aster

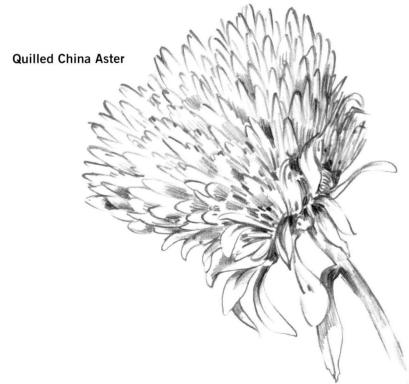

A

B

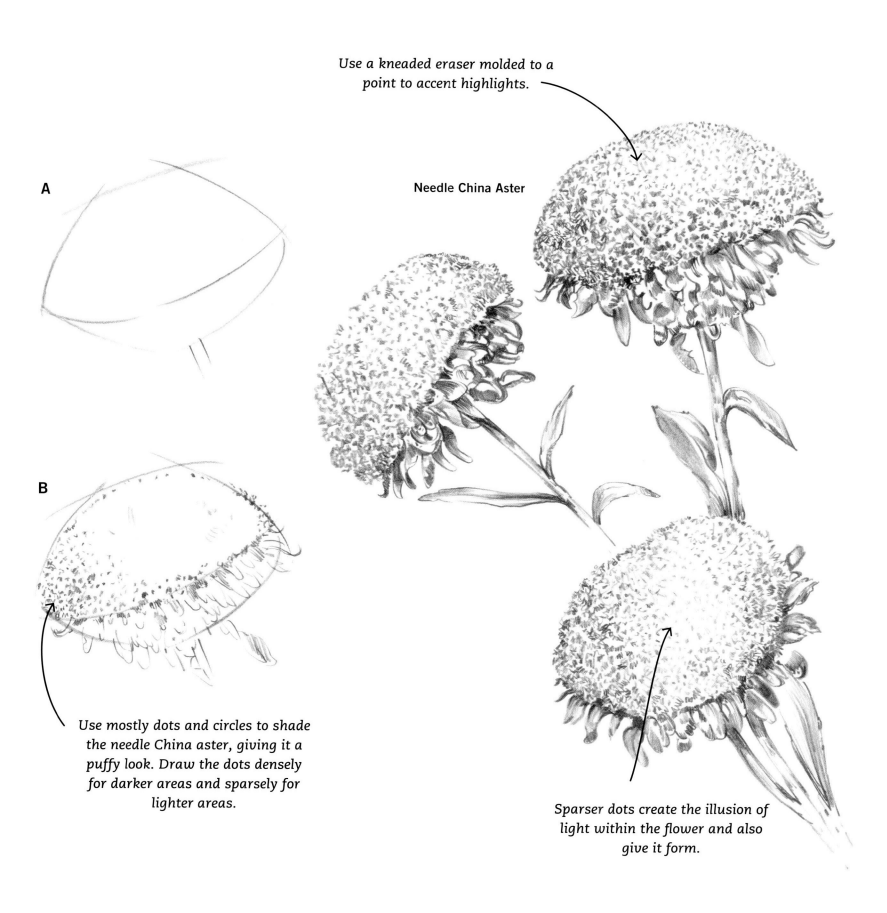

Use a kneaded eraser molded to a point to accent highlights.

Needle China Aster

Use mostly dots and circles to shade the needle China aster, giving it a puffy look. Draw the dots densely for darker areas and sparsely for lighter areas.

Sparser dots create the illusion of light within the flower and also give it form.

BEARDED IRIS

The bearded iris is probably the most beautiful of the iris varieties. Its colors range from deep purples to blues, lavenders, and whites. Some flowers have delicate, lightly colored petals with dark veining. They range in height from less than a foot to more than three feet.

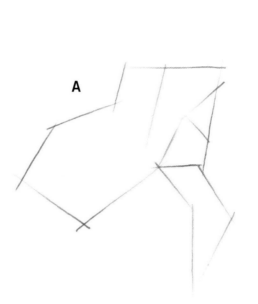

A

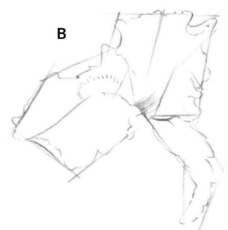

B

Follow the arrow directions in step C for blending and shading strokes; these strokes make the petal surfaces appear solid.

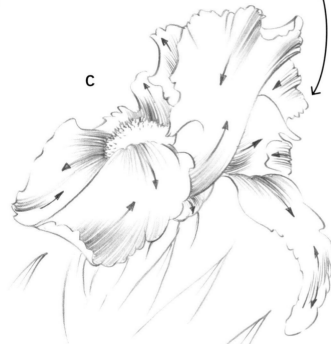

C

Step A above shows the block-in lines for a side view of the iris, while step A below shows a frontal view. Whichever you choose to draw, make your initial outline shapes light, and use them as a general guide for drawing the graceful curves of this flower's petals.

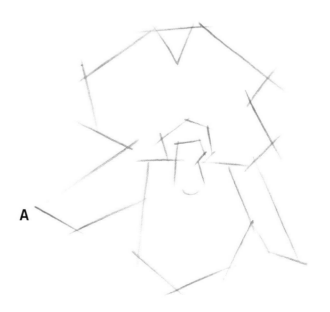

A

Darken shadowed areas using the point of a 2B.

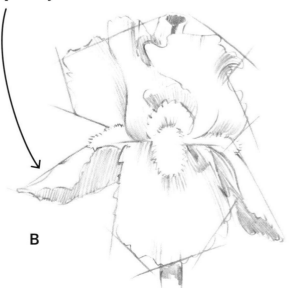

B

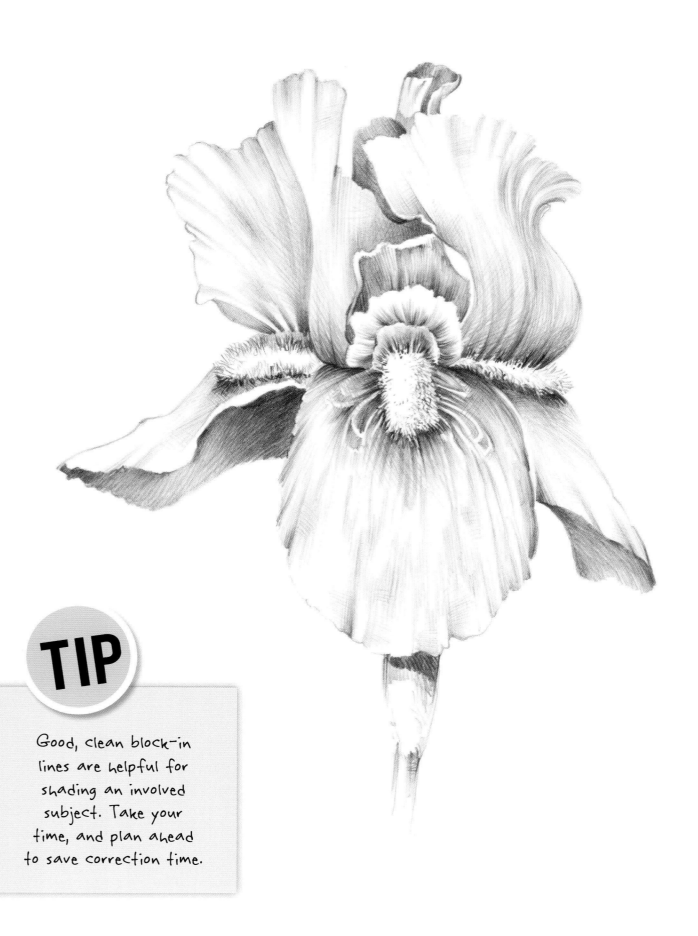

TIP

Good, clean block-in lines are helpful for shading an involved subject. Take your time, and plan ahead to save correction time.

BEARDED IRIS (CONTINUED)

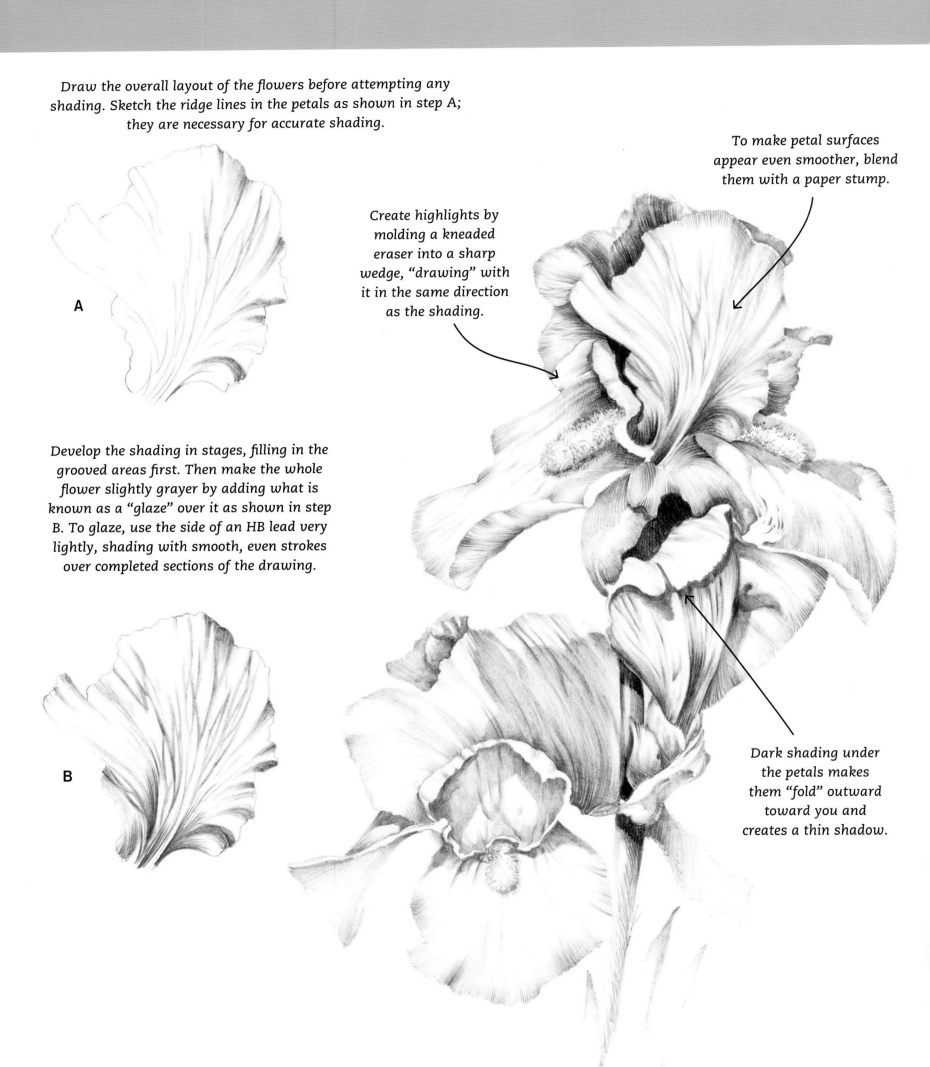

Draw the overall layout of the flowers before attempting any shading. Sketch the ridge lines in the petals as shown in step A; they are necessary for accurate shading.

A

To make petal surfaces appear even smoother, blend them with a paper stump.

Create highlights by molding a kneaded eraser into a sharp wedge, "drawing" with it in the same direction as the shading.

Develop the shading in stages, filling in the grooved areas first. Then make the whole flower slightly grayer by adding what is known as a "glaze" over it as shown in step B. To glaze, use the side of an HB lead very lightly, shading with smooth, even strokes over completed sections of the drawing.

B

Dark shading under the petals makes them "fold" outward toward you and creates a thin shadow.